SEVEN YEARS WITH BANKSY

ROBERT CLARKE is a son of Bristol but was brought up in Cotswold valleys. He came of age in Thatcher's Britain and has spent a third of his life travelling the world. He has held down dozens of jobs, from building to cycle messaging in Manhattan, NYC. He currently lives in Sweden with his wife and children and works as a writer. In summer he can be found sailing in the outer skerries of the Stockholm archipelago. His motto is, 'Be not conformed to this world' (Romans 12:2).

SEVEN YEARS WITH BANKSY

ROBERT CLARKE

Michael O'Mara Books Limited

First published in Great Britain in 2012 by
Michael O'Mara Books Limited
9 Lion Yard
Tremadoc Road
London SW4 7NQ

A CIP catalogue record for this book is available from the
British Library.

Papers used by Michael O'Mara Books Limited are natural,
recyclable products made from wood grown in sustainable
forests. The manufacturing processes conform to the
environmental regulations of the country of origin.

ISBN: 978-1-84317-865-1 in paperback print format
ISBN: 978-1-84317-893-4 in EPub format
ISBN: 978-1-84317-892-7 in Mobipocket format

2 3 4 5 6 7 8 9 10

Designed and typeset by Design 23
Cover design by Ana Bjezancevic

Printed and bound by Rotativas de Estella, Spain.

www.mombooks.com

To my family

INTRODUCTION

It seems that a great number of people nowadays are very interested in this character known as 'Banksy'. They have been for some time, of course, but just now, as I write, with his exhibition in Bristol this is reaching a fever pitch. The queues into the Bristol City Museum were hundreds strong, and even little old ladies had the shaky temerity to ask 'who is Banksy?'

There are many people who know him, though, whose tenacity in 'schtumness' and 'quietude' is a testament to friendship and a response in kind to his own nature. And therein lies the rub. Huge sums have been offered for pictures of him – and there are many around. Even my mum has pictures of him. But who is he? His SOUL is the major factor I am interested in. What is he like? Why does he do what he does? Why does he not desire fame like everyone else? How often do we actually meet someone who is not scared by other people's reaction? Who is true, sincere and with their own take on

things? Banksy's rejection of fame has, in this media-saturated environment, only served to enhance his anti-fame.

Which is one reason why I wanted to write this book. The real questions and answers about him can be revealed without his identity ever being known. He speaks through his art. However, as a friend I can explain something of his make-up, perhaps, that will give depth to his creations and his character – he needs this or there is a chance he will be seen as being ephemeral. For me fame is a grotesque vulgarity sought out only by the insecure. It makes you an easy target for the media and who needs to be pursued for the amusement of others? It's soul-destroying. It just isn't worth it. For some people though, like Banksy, this kind of attention is anathema to them.

The other thing one must consider is the illegality of the art form. For years this geezer has been wanted by various authorities for the prescient act of daubing on walls. He is well

aware of what the authorities would like to do with him – set an example and all that. By prescient I mean that what you see on a wall boldly painted by someone often projects into the future; it's powerful and effective – and the status quo doesn't like it. They never have and they never will, because they can't control it. But if you can pay through the nose for a billboard, you can say virtually anything you like. And as citizens we all have to swallow the messages of envy and greed from our 'friendly' corporations because they have created laws saying that kind of indoctrination is OK. It's been paid for. And every graffiti artist I have ever known, including myself, understands that. Adverts are as far from the truth as it is possible to get. They represent the utopia that you must pay for as you slope through your trashy end of town without a penny to scratch your arse with. But to go out there in the dead of night when even the dogs are asleep and to put up on a wall a picture of the way you, as a free citizen, see this whole set-

up is to have the courage of your convictions so the general public can witness how you see it, for free. And we all know graffiti can be exquisitely poignant and beautiful, more than any advertiser can co-opt or come up with. As long as there are advertising billboards there will be graffiti and there is no contest as to which is the more creative and true. So forget having a clean-walled town for the foreseeable future.

For more than a decade now Banksy has put up fresh work all around the globe. And untold numbers of people have seen the world through his lens, at no cost, and had a sense of liberation as a result. The dude does it because it is what he does. End of.

CHAPTER ONE

NEW YORK

In 1994 I found myself back in New York. I had been travelling around the Middle East with my brother after my father had passed on and had stopped in Bristol for the summer. I had this unquenchable lust to be back in New York and even though I only had a small amount of money left, I got myself on a plane and headed over the Atlantic.

By now I felt I had developed a relationship with the place, having first visited New York in the harsh winter after John Lennon was shot down in 1980. Those were the days when you would see a subway train screeching into a station that had been bombed (covered in graffiti) massively inside and out. They were like living, breathing works of art coming at you non-stop. When the doors sprang open, every square inch was tagged. It was another world and it exhilarated me. I would sit and watch the trains coming over from Brooklyn on the bridges and trip.

I loved the graffiti and back then there were no glossy coffee table books fetishizing the subject. It was just hyper-real. As a kid just out of his teens this was like being in a Kojak thriller all of my own. When I was back again around 1984 most of the trains were clean but you saw Keith Haring and Jean-Michel Basquiat works on the subway walls instead.

By 1994 the city had changed its nature again; it seemed a tamer place but it still retained a raw edge. Since 9/11 New York has become so sanitized it barely resembles its heyday and I, like many others, have fallen out of love with it. But I'm glad I'm no longer addicted to the place.

To set the scene: in 1994 I came rolling out of JFK and on to the A train heading into Manhattan. I got out at St Marks Place and strolled down 8th Avenue to Tompkins Square Park in the East Village where my mate Max lived. He was only going to let me stay with him a couple of nights so I had

to act sharp to get sorted. A place to crash was obviously a priority: the nights were drawing in and the big freeze of winter was on its way.

I struck lucky and hooked up with Max's ex-girlfriend, Phlipp, an English girl who I knew from London, and she threw some good fortune my way. Within those two days she found me a place to stay – a warehouse space over in Williamsburg, Brooklyn. It was just one stop on the grey L train from lower Manhattan, and back then it was only just starting to be populated by artists converting old warehouses and industrial spaces into living quarters. Spaces could be huge and rent minimal, just how artists like it. Now the place is expensive and full of young trendies living the high life. Back then we were sandwiched between Poles, Hispanics and Hassidic Jews, and there was only one or two places to eat. The City changes and money moves the underprivileged out. In '94 it was a decidedly righteous place to live.

My room was basic, with access to an adjacent roof from where you could take in a view of the city. There was a nest of rats down my stairwell but as long as they didn't come into my room they never bothered me. About twelve of us shared a bathroom but it was all good and functional. I was established in living quarters in the Borough of Brooklyn.

It wasn't too long before I needed to find work. I had an old Social Security number that a friend had procured for me when I had lived in San Francisco. It was dodgy but I could use it for a while before the wheels of bureaucracy would catch up. Meanwhile Phlipp had just quit a job working at a low-rent hotel in midtown. She had had enough of the place but offered to introduce me to the crew that ran it as they might need someone to fill her shoes.

I went to check it out – the Carlton was no normal hotel. It was one of the best located but cheapest places to stay in town. It was an

old, crooked, funky joint that used to house whores, crack addicts and various lowlifes. There were some dignified old-timers who had resided there for years and some loons who just holed up there, washed up from some personal crisis, and had never left. But here's the thing: artists, of one description or another, had begun to stay there due to the affordable rents. At some point one of these artists had offered to paint their room instead of paying rent. The management took an enlightened perspective and said, 'Yeah, okay, paint whatever you want.' Virtually all of the rooms had been painted by different people in different styles, so much so that the place had an international reputation and various artists would even fly in to stay for free while painting their room.

The first day I walked into the place it was a sensory overload – the hallways, toilets, foyer and stairwells were all decorated in styles that grabbed your attention, not to mention the rooms. I was introduced to the

crew that ran it. They looked me up and down and made me a cup of something before I left but it didn't seem that I was going to walk into a job right there and then. So I was back on the street, rubbing my hands in the autumnal air and feeling a little disappointed as the place had taken hold of my imagination.

Now, the neighbourhood I had moved into was not completely new to me as I had another link to the area. Her name was Dominga, a Brooklyn born, Chinese-American of Singaporean extraction. She was previously married to Scott, a mate of mine with dual British and American citizenship. He had been living in Williamsburg and we used to hang out over there back in the day. I went over to visit and told Dominga I was wondering about how to make some rent when she said: 'Hey, what about being a cycle courier – you can borrow my bike.' So I got downtown to a courier service the next working day and signed up.

I knew the city quite well from my previous visits as I had lived in a number of neighbourhoods since 1980 such as 'Hells Kitchen' the old Irish 'hood, the East Village, Lower East Side, Spanish Harlem, and I also had friends all over so I figured I would soon find my way around. I had to cross over the infamous Williamsburg Bridge every morning and night, something I had been warned against doing by everyone I knew, but I was adamant nobody was going to fuck with me and got it on.

It's a serious job, as anyone who has been a cycle courier will tell you, and the reward is certainly not the money, although it's enough to get by on. The reward is getting to know the city. You are granted instant access to a multitude of places and faces that are strictly off-limits to the general public. It was dangerous out there; cold, wet and hard, and that was even before you started working, but the other couriers were brothers in arms and slowly the city revealed itself to me.

One winter afternoon I was belting up the Avenue of the Americas on the bike when Keef, the boss of the Carlton Hotel, shouted out to me from the sidewalk. I screeched to a halt in the slush. It turned out he had also been a cycle courier for some years so he had the camaraderie in spades. He was psyched to see me doing what he used to do and it turned him onto me more than our previous encounter and he mentioned there might be some night shifts available at the hotel if I was still interested. I told him I was and gave him a contact number. It wasn't long after that I got a phone call and I was invited over to the Carlton to be trained up in the art of the night porter. Soon I had enough shifts to leave the courier's slog behind me. The refrain from E.S.G.'s tune 'Uptown downtown, you've got to turn your life around' began to leave my head.

I started to do eighteen-hour shifts at the Carlton Hotel. It was excruciating to be woken at 3 a.m. by some drunken bum

who wanted a bed for the night, but on the whole it was an easy number, even though I worked alone at night. Foreign tourists had started to show up and use the hotel and it was interesting to talk to the international clientele.

The bolloxed and banjaxed folks that passed through the doors was worthy of a book in itself: there were the crack-smokers and -dealers who we would try to screen but some would fool us with a straight appearance; there were the assortment of whores of both sexes who came in with their customers to turn a quick trick, and then there were regular people who happened upon us on account of the good rates. Finally, there were the artists who would usually stop over one at a time and there would be a break before another showed up. These individuals were nearly always impressive and worth getting to know.

The centre of operations was a tiny office, full of junk and odd artefacts with an

even smaller room off to the side that had a bunk in it (and a baseball bat) where you could hopefully catch some sleep in the early hours when it could get quiet. It was one of the most pleasant parts of the job to invite a guest into the office and have a cup of tea and shoot the breeze.

After a few months one of the day managers mentioned that we had an English artist staying for a tour of duty and that he was from Bristol. 'You're from Bristol aren't you?' he said.

I looked forward to meeting this person. Lo and behold, one fine morning, bleary-eyed as I was, there stood before me a guy by the name of Robin. He was framed in the office door and a radiant light was coming off him... no, not really! There he was, framed in the door and he just looked at me with a nonchalant expression.

He didn't say anything so I said, 'All right?' He nodded and I spoke again and said, 'You must be the one from Bristol?' He

nodded again but didn't communicate much else. He was just there. 'Is there something you want?' I asked. He had some personal effects in the little safe, so I gave them to him and he said, 'See ya,' turned and walked off. 'Oh,' I thought and got on with what I needed to get on with at that time of the morning like turfing out the bums before 10 a.m. and getting the books square.

So that was our first meeting and it makes me smile because that non-committal long gaze thing is him through and through. He isn't very forthcoming.

A brief description: he is quite tall but not overly so, he is slim and slightly gangly. His dress sense isn't really together. His clothes didn't make any sense. He wasn't trying to concoct a look or identify with some youth code. It was nondescript. The guy was a crow, he didn't stand out, or in; you just wouldn't notice him. He could blend in or out at will as if he had an invisibility cloak. This was my fundamental impression when I look

back at those three short minutes when I first clapped eyes on him. To be that way requires some magic spell or something and I don't think he was conscious of that effect – he was born with it. This is the first clue to how he's managed to go so long undetected. And long may it continue.

After that first inauspicious meeting I can't say I looked forward to seeing him again. He was just there, in the hotel, doing his thing and it was my job to keep an eye on him.

So I was doing my shifts on reception, often eating a pint of Ben and Jerry's 'New York Super Fudge Chunk', while this new artist would come and go through the foyer. It wasn't an open reception. We had bullet/baseball bat-proof security glass fronting the office with a space to speak through, just in case of any antisocial behaviour so often displayed by disenfranchised New Yorkers. But we did have a door, naturally, and that was usually open.

Robin and I started to nod at each other from day to day but usually he would just pass by, quite rapidly. 'What have I done to offend him?' I thought, although in truth this was really my least concern. He knew I was English, but we English are very cautious of each other, especially when we're abroad. Rather than a chummy acceptance of another Englishman, it is usually a long-winded process of just getting to know each other a little at first. Where this foolishness comes from is anybody's guess but there it is – English reticence – yet when we do connect it is usually solid and lasting.

I knew he knew I was English, but maybe he didn't know I was from Bristol, so I decided to go up to his room uninvited and introduce myself properly.

CHAPTER ONE: NEW YORK

CHAPTER TWO

SIDEWALKING

One evening I made my way up to Robin's room. There was an appointed time when I shut the street doorway at night and then I would walk the hallways, just to make sure there was no anti-social trash hanging about. I would do this a few times each night and early morning. As I came towards his room there was the usual smell of paint and the door was shut so I knocked. There was no response from inside so I opened the door a little and stuck my head through the gap.

'All right?' I broached.

'Yeah,' he said.

'Can I come in?'

'Yeah,' he said. So I stepped inside.

The place was a wreck: paint all over the place and stuff everywhere, but on the walls something was coming together, including the ceilings and doors. Odd, cartoonish, fiendish-looking creatures were beginning to peek out in broad outlines and bright colours. It was like a Gremlins toy town manifesting through the walls. So this is

what he does, I thought. I didn't comment much but said 'Hey, looks all right.' 'Yeah,' he said.

I didn't feel exactly welcome but I sat on the floor and relaxed. He was working and you know what these artists are like, so I settled back a bit and just started to chat a little, talking a bit about Bristol and whatever but it was pretty quiet generally and I watched him work. The atmosphere became warmer as the minutes passed. He was very busy, immersed in his work. After a while I realized I had been in there for over an hour. It had been nice to sit there, trying to figure the newcomer out, seeing him in action, but I had to go and sort the laundry and answer the phones and do the books and be around for the residents so I took off.

His artwork looked like fun but it wasn't as serious or avant-garde as the usual stuff that got done in the rooms. Mind you, some of the rooms had been done out so heavily that it was depressing to go into them, and

some had such explicit sexual references it made you wonder what sort of behaviour was demanded of you if you stayed there. One room was full of depictions of car crashes and flowers and that really got to my mum when she stayed in it. So Robin's room was definitely staking out its own ground. It wasn't traditional graffiti as some might expect. It was something else, like the Wacky Races with a macabre tone. I liked it but it didn't particularly challenge you in any way and I wondered how the hotel became interested in him. It almost didn't seem to fit the place.

Ah well, just another visiting artist, I thought. I also figured he might not be around that long as the usual artist tenancy was a couple of months at most. Although he was British, there were no real gestures of friendship and as he was quite aloof, I just let it be.

As time went by though, I would invite him into the office for a cup of tea and the English reticence thing started to melt a

little and mutual acknowledgement became more regular. His room was coming along and he had started to occasionally bring around some people he was hanging out with. They looked like proper New Yorkers and lacked any pretentious airs that are sometimes common among creative people. Little parties began to take place in his room and when I was walking the halls in the evenings, the door was often open and I would pop in and have a beer, meet his associates and take in the advancing jungle world that was appearing on his walls.

I think he was testy with me because I actually just worked there, 'a member of the staff', and we hadn't crossed into a space of mutual trust that you need to let people in. The reality was I didn't give a damn about how crazy it got in the hotel. I liked the madness and insanity of the place. And in contrast with the vomit-soaked rooms and firearms his vibe was quite chilled out and cosy, if a little standoffish.

A young blonde girl attached to him showed up on the scene and you just had to look at her to see she was wild and spiky. She was on the punky-street side, and chased after him like a young puppy with her tailwagging. You could feel their energy before you saw them coming in off the street clutching bottles of American Sudsy beer wrapped in brown paper bags.

Late one warm summery night I noticed she was in his room and there was a lot of high-pitch screeching going on that sounded like a heated argument. I hadn't seen her come in with him, or on her own. The street door was locked , as it usually was at such an hour. I'm not sure if he saw me pass by on my rounds as his door was ajar, but he came down later and he seemed exasperated.

'She climbed up through the fire escape,' he said, 'and came in through the window. I had no idea she was coming. She's crazy; I can't get rid of her!' 'Oh yeah?' I said, and at that moment she came running down

the stairs bouncing around like a toy doll. I'm not sure what she was on, maybe it was natural, but she became a fixture for a while and I was pleased to see them together.

Robin moved out of the hotel and I didn't see him for a while. Life went on in New York and I continued on my night shifts and pursued my fancies. One of whom came in the shape of an attractive young Swedish girl. I couldn't help but notice a new energy in the hotel when four Swedish girls arrived. Their effervescence was infectious, they turned the heads of even the oldest residents, especially old Charlie Berg, a veteran of the Second World War who ate his breakfast in the office with me most mornings and who had Swedish heritage. He would mutter and mumble under his breath when they passed.

They were studying at Parsons, a famous art and design college in Greenwich Village and were soon to move out to an apartment. When one of them left her architectural ruler

at the hotel by accident, I took the chance to invite her to tea with me in the office one balmy afternoon. Soon we started going out so I had a new relationship to occupy my time. Her name was Johanna.

Soon afterwards Robin showed up and said he had been staying down in South Brooklyn, a place known as Red Hook. I had been down that way a couple of times as I was eager to explore every nook and cranny of the city. There wasn't much there to speak of; it was a heavy ghetto basically comprised of African-American-inhabited housing projects. The area was (and still is) hardcore but not famous like Bedford-Stuyvesant.

I was astounded and thought, 'What the fuck are you doing down there, man?' Robin was staying with some people he knew and we got to talking about the place. He told me he had walked into the local fast-food joint late at night – a soul-food place – and had tried to spark up a conversation with the locals, as you might do in England. He was

met with a less than welcoming response: the people there just all set their eyes on him with more than a hint of menace. A 'Who the fuck is this white boy with a fucked-up accent? And what the fuck is the mother-fucker doing here?' vibe. I had felt the same thing many times while up in Harlem or the Bronx, so I knew what he was talking about. The truth is New York (and America) is a very segregated land and Britain feels different to that. Robin's friendly attitude was his Britishness as much as just himself. His genuine openness as opposed to fear or more negative attitudes is probably what saved him from having his arse kicked around the block. 'It ain't like at home,' he said, 'like Paul's or Easton.' 'Yeah,' I agreed. I even had British Caribbean friends in Brooklyn in certain neighbourhoods who would say 'watch yourself round here mate, it ain't like England'. I was amazed and impressed that Robin was living down there and wondered what he was putting up on

the walls and streets and what the Red Hook residents would have thought of his art. They probably dug it.

I spoke to him about some of the New York neighbourhoods I had experienced and we talked for the longest time so far, and when I look back, this is the point when things started to open up.

From then on we started to hang out together. It wasn't because we were English or that we had the common connection of Bristol. Far from it. It soon transpired that he was a Bristol City fan and I am a Bristol Rovers supporter so we were never going to bond over our local football teams. We were Englishmen in New York.

The hotel had offered him the foyer to do out and he took them up on it and became a summer fixture in the place. This time around his work was still leery and on the comic edge but on a grander scale with scary beasts and monsters lining the walls as if they were residents of the establishment.

It was good fun, sharp and had his unique humour running through it. I liked it but it didn't seep into me too much, not like his later work. He was doing this thing and I was there doing my eighteen-hour shifts.

One of our first excursions was to a nearby Irish bar to watch an English football international. It is always a laugh to congregate with English compatriots in a strange town with the common bond being the English national side. It's an instant hit as you walk in. English energy, the looks, the clothes, the chants and singing, the beer-swilling, the nervous looks from the locals (even in New York). Through that Robin and I became more relaxed and I began to figure him out. He was still aloof and distanced but I got the feeling that despite his endeavours to not reveal himself, he was deep.

This unfathomed depth is important because this was a formative period leading up to his prominence as the artist he is today. He was young, he was inspired by

New York and although he had a lot of 'suss' and knowledge already, he was beginning to find his feet, sort out his own perception of things, and fine-hone that vision, for nobody else's sake but his own. He was out there doing the deed in the dead of night in volatile, dangerous places, not in search of accolades but because he wanted to get his views out there. To capture people's imagination was the only reward.

The point is it's all about thinking for yourself – because the powers that be try to think for you from cradle to grave. And that's why Banksy is so good. He truly thinks for himself. And he doesn't just think for himself, he puts it out there for all to see, to reject, to agree with, be provoked by, enlightened by – all of that stuff.

There was a Jewish mayor of New York back in the '80s - Mayor Koch – who once said 'If you've been here for six months but you're moving faster, talking faster, then you're a New Yorker.' And I hold with that.

The place can do something to you, animate you, make you more up on your feet, more up on your wits. Several people have asked me, 'Why do they call New York the Big Apple?' I'm not sure of its origins as a phrase but, to me, it means that everybody can take a bite. It's big enough for all comers to savour its flavour. Just go ahead and take your bite and enjoy it. The City laid itself out in all its expectant glory – a myriad of spaces and places to check out, scenes to get involved in. And nobody minded too much about you. They just got on with their own thing and when you connected with like-minded people it was a double-plus good.

I was seeing Johanna a lot and there were a ton of parties about, often in Williamsburg. Robin and I began to go out together some more. We'd walk some of the city streets and the spectacle of the town worked its magic. One afternoon we strolled down Broadway to a gallery around Soho, close

to Canal Street. We had both heard of the artist previously but the name escapes me now. This was a street graffiti artist who had a formidable reputation and had now begun to show some big pieces on canvas in galleries. I can still see the work in my mind's eye and we were both impressed and pleased to see the exhibition, to take in its visual manipulation.

The canvasses were as big as your average door and the movement of form or letters burst out and rushed back into the art. The hues of blues and colour were so subtle and harmonious they reflected a mind-state that was one: tough and two: sublime. This was good. We spent some time in there while Robin said repeatedly 'This just does something to my head.'

He liked it a lot. He was hardly a stranger to graffiti and could easily do his own pieces but this was advanced and you got the sense that he knew he couldn't compete with the standard, maybe ever. He did say later

he didn't think his graffiti pieces were that good, in the traditional sense. I also think that pointless pursuit of the conventions of the genre was too conformist an approach for him. He knew his limits and that is when he started thinking out of the box.

He has famously said that he came to stencilling after he saw a stencilled number under a train carriage while concealing himself from pursuing law officers. Its simplicity and cleanliness appealed to him at the same time, being a direct and quick method that was not as time-consuming as when you put up a big piece. This meant he could hit and run with clinical precision many times over on one night. He found his own way and took full advantage. He started with one stencil only and then realized he could do huge pieces with many stencils placed together (like his 'Mona Lisa with Bazooka') to achieve maximum impact. In New York, however, I never saw him use or create a stencil. That was going to come later.

We were out one day walking through Soho and I thought of popping by a market-place where I had worked a little and had some trader-friends who were English and I introduced Robin to them. We all got on well and were having a laugh but soon Robin was tuning into this younger kid and they both clicked as they figured out quickly enough that they both wrote graffiti. Robin and this lad were rabbiting on nineteen to the dozen about all the local graffiti artists, the names of whom I'd never heard before. The knowledge was impressive and I was out of my depth in this context so I just listened and that's when I realized Robin was way out there in his familiarity with this scene. They were almost like a couple of train-spotters. They spoke in reverent, excited tones of artists and places to find the best, newest pieces by the most invisible, law-defying street artists in New York.

That was another 'click' moment. He was up on stuff and knew details that I had

no inkling of. This scene was his thing; he was becoming embedded in it. His artistic persona was getting more solid. He was the proverbial iceberg: you see a little above the water but underneath is the hidden mass. He didn't show what was concealed and it's pretty much the same to this day. He's only going to talk through his art.

We would quite often walk out from the hotel together after my shift was done. This was usually around 11 a.m. when the Manhattan mornings were often bright and felt full of endless possibilities. This particular morning, we were both riding skateboards and I suggested we move on downtown to the lower echelons of Soho to take in an exhibition showing the anarchist propaganda, art and posters from the Spanish Civil War. It was something I was interested in, having read various accounts of the anarchist International Brigades fighting the allied fascist forces of Franco, Mussolini and Hitler at the same time as

the Soviet-backed communists. There were many westerners in the anarchist brigade, not least British and Americans who gave their all for the cause. I was mentioning these facts to Robin as we skated on down. He seemed interested but remained quite silent.

It's a complex and often overlooked part of history and I thought it would be enlightening.

We got to the gallery relatively early, it had just opened and there was no one inside apart from the proprietor. As we strolled in he looked up, slightly disdainfully, as we propped our skateboards up against the gallery wall. This guy couldn't have had his coffee yet because he immediately took off on a tirade about how 'we shouldn't have done that'. It was so out of proportion and snotty that I railed down on him. Pointing out how small-minded he was being – especially in contrast to the noble theme of the exhibition around us. It became a

stand-off and I saw it through but Robin stayed quiet and hung back as it was clearly becoming embarrassing. Eventually and predictably the proprietor said, 'get out of here before I call the cops'.

It was a stupid event, but to me the gallery owner's hysteria was beyond a joke. Robin wasn't happy about this scene and I couldn't really make him see it my way: that this man was childishly reactionary about a couple of skateboards when he was hosting a serious revolutionary art exhibition. To me the irony was obvious and absurd but it created a cold space between Robin and me and he took off soon after, leaving me feeling nonplussed by his reaction. But there you go; I wasn't about to turn it into a big deal. To me he was just another snooty Soho gallery owner.

While in the gallery, though, I had seen a notice that said there was to be a gathering of ex-combatants from the American branch of the International Brigades that night,

including speeches from some of them, so despite the upset I resolved to return. This meeting meant something to me and an uptight fool wasn't going to put me off.

So that night I dressed differently, put on a 'poor-boy cap' and got myself down to the event. And it was truly worth it to see these brave men and women stand up and tell their stories: how the US military rejected them for their effort and even how, on their return to America, the unions would not let them be hired simply because of their political beliefs.

They all stood at the end of the evening and sang 'the Internationale' and they were still strong and proud and righteous and it struck me hard in the heart. As I left, I passed the gallery owner once again and checked his gaze as he did a double take.

I didn't run into Robin again for several days and neither did I seek him out, but, of course, we were bound to see each other and I was determined to bring up this incident.

The next time I saw him I was in the hotel office on a fine afternoon fixing up a shitake mushroom salad. He came in with Mike Tyler, the resident poet and writer who was staying in the hotel – and was forever stalling on his rent. Mike was one of the founders of the 'Slam Poetry' events in New York that later evolved into a worldwide scene. He was an interesting guy and also never had a dime. So I asked them in to eat and they were pleased to join me. I always made a little more food than necessary and often invited others to eat with me. It made for a pleasant intro to the night shift. And we got to talking.

I already knew that Robin was naturally taciturn and since the gallery episode he had retreated a step back from our friendship. So, fuck it, I just gave him a broadside and told him how I had gone down there again that same day to pay some respect to the old warriors. I told him about their clenched fist salute, how the establishment back in

the States had blackballed them, ostracizing them and their families. He started to see things differently and silently acknowledged where I was coming from. I didn't know if he had any politics. His art at this point did not reflect that but to me it was obvious he was smart, streetwise and a guttersnipe. And the truth is only known by guttersnipes. So I thought, 'hey – we're either going to connect or not'. So I laid it out and our relationship was better for it.

Life in New York moved at its own rapid pace, and Robin and I continued to hang out. I took him over to Williamsburg one time for a brunch being prepared by a crowd of the artists that I lived with. I remember he was pretty quiet, as usual, but I could start to read him by then and I could tell he was intrigued. His style was to be quiet, to observe, to take it all in – and then he would come out with just one comment at the precise time to garner some attention. And that is what he did on this occasion, successfully

pissing off half of my mates with deceptive ease. Usually his perceptive comments were so close to the target they got most people's backs up within microseconds; others would laugh; others would be puzzled. But when he spoke all would listen. I've seen him do this 'cat among the pigeons' routine several times and it has this canny effect every time. He could smell bullshit a mile off and he could cut fiercely through the pretensions of a crowd. It was just quick, short and precise. And almost every time there was this humour – the same humour you see in his art, especially the stencils.

He was never great for conversation. He didn't do that, he didn't reveal or divulge often but they say that only about 30 per cent of human communication is actually spoken or verbal. But people who talk too much have always bugged me; you've got to get your psychic awareness out, feel the other person. With Robin it was always just good to be around him. You felt like you

were with an intelligent, deep animal but you wouldn't think of crossing him. His razor blades were just too sharp. I got an idea of his background and there wasn't a sniff of privilege about him. His wit and sensibility came from hard knocks, you could tell. He comes from nowhere and he could go right back there in a second and not be perturbed.

In hindsight, I was very glad to have him in my life back then. He was a complete antidote to the superficial entities that inhabit New York in large numbers. I'm not going to say we were kindred spirits or anything like that but we didn't stop hanging out. Our friendship was ongoing.

He had an edge, as I mentioned, but he didn't have any particular politics or dogma. He just saw things clearly. He wasn't really influenced too much by anything but I could feel his keen sense of injustice and hypocrisy.

I was starting to make plans to leave town and head off for South America. I'd been saving money and even had enough

to buy a second-hand Harley Davidson and ship it back to England. My first idea had been to ride across to California to hook up with some good people I knew. However Johanna put paid to that idea as we were in love and she became my priority. Her stay was also coming to an end and I was determined to get over to Sweden as soon as my South American trip was over. Also I wasn't getting on too well at the hotel with certain members of staff, one of which was working on getting me out of the place, saying that I was too rude, which still makes me laugh when I think of it.

There was a buzz in the hotel office a couple of mornings running, more so than usual. The place was usually humming by around 10 a.m. Old Charlie Berg, the war-veteran, would be ordering his breakfast from the corner restaurant over the phone 'and make the eggs over easy, dammit...' while a fusty smell reeked off him, guests coming and going, money to collect, questions,

complaints, and more questions. Robin would poke his head in, slightly bemused by the goings-on and to see me fencing off all the usual rigours of the job. 'Hey, they call it work!' I might say to an enquiring gaze.

But this morning the buzz was: Damien Hirst was coming through town – and how the hell were we going to blag our way into the opening night? These were relatively early days for Hirst in New York and this was to be his breakthrough show. He is quite entertaining, but to be honest I couldn't really take him that seriously. Nevertheless, I was into checking out the opening night. Whatever else he does Hirst has a skill in the art of extracting largesse out of corporations that have too much money to burn.

What caught my curiosity was that Robin was genuinely excited at the prospect of seeing this *enfant terrible*'s collection. I hadn't seen this kind of interest shown by him for any other established artist that I could think of; in fact we rarely even spoke

of any contemporary art scene at all outside of graffiti. It was revealing because Robin was motivated enough to get in to the opening by hook or by crook and as the days passed you could tell he was anxious about the prospect of not being able to get in – it being invitation only (and none of us having invitations!).

As things transpired I couldn't go: it was a working night I hadn't counted on. So I had to make do with him telling me about it later. The night of the opening Robin stopped by the office before leaving and he was almost glowing with expectancy and suppressed excitement. I was surprised because I hadn't seen that reaction from him before. 'Shit, he's really into this bloke,' I remember thinking, and as he left I wished him luck on getting in.

The next day I was again surprised to hear how impressed he was by the show, and he described the atmosphere, the people who were there (like David Bowie) in glowing terms. He was so tuned into the whole thing.

To be as good, in his own way, as Hirst, to be so well known, to have a certain type of person expressing interest in your art, this was a turn-on for Robin that I wouldn't have envisaged up to that point. Now I see it clearly. In his mind already he had vague ideas of where he was going, where he wanted to be; he had his motivation click-clacking like a whirring machine in some part of him. 'He wants to go places,' I remember thinking. And with hindsight it is noteworthy that Mr Hirst, another West Country boy, could be said to have taken Robin under his wing a little.

I went down to the show the following night, it was interesting, but it showed me more about Robin than anything else. I began to see that I was lucky to be spending some time with a genuine, talented, singular maverick that had a bright future ahead of him. This period in New York was a formative one, a beginning of sorts and an education of how to move on to the next step – there was a certain calculation on his part, but basically

it was an organic process of growing, of branching out, of bearing fruit.

I would have liked to have left the hotel before they fired me but all was not fluffy bunnies in the job. Something was up, I could smell it, so I decided to make a move. I think Robin felt I was going to be moving on and he started to be more forthright in conversation when we were together. He seemed to be forging ideas around me, sounding them out and maybe he was trying those ideas out on others too, but I was listening.

At this point I could feel he was gaining in confidence and self-assurance. One afternoon he came into the office and started going on about his name. His first name is Robin, as he was saying, and he was thinking of changing his last name to Banks; that's right, 'Robin' Banks' (later abbreviated to the tag 'Banksy'). He brought up the idea of this name-change at least three times on separate occasions and just ran it by me, looking for affirmation. The idea was that

anything he did would be attributed to this moniker – Robin' Banks – a deliberate pun. However, I knew the name was too long to use as a graffiti tag so thought he must have other ideas for his art and other projects in mind. Over time the pseudonym 'Banksy' just came into common parlance, despite his original intentions, and I can't say I have ever heard anything he's done credited to a 'Mr Robin' Banks', but for those who wonder why he calls himself 'Banksy', now you have your answer. Eventually, after being at the hotel for a year or so I was out and back on the bike as a courier. I wasn't fussed because I had never planned on staying in New York for too long. Even that town can get boring after a couple of years of living the life.

As a result I didn't see Robin as frequently but when we did hang out, most often at certain bars in the East Village, our talking increased a little in urgency. I began to ask him a few things about who he knew in Bristol. 'Have you heard of The Pop Group, Mark

Stewart and The Maffia?' 'No.' These were critically acclaimed bands from Bristol that came out of the punk era. They had a serious political edge, preceding virtually all other acts internationally at that time. No, that was too early, it wasn't his generation. He knew of Massive Attack, Tricky and Portishead but it didn't seem that he knew them personally in any way. I went on to talk about the 'Dug-Out' club in Bristol where everyone used to hang out back in the day and where the Wild Bunch, later to form Massive Attack among others, had their roots.

He wasn't really aware of that. Then we started talking politics: 'Have you ever heard of these secret covert groups – the Trilateral Commission, the Bilderberg Group, the Masons, these fuckers that try to control the world from behind closed doors?' I asked. Robin said he wasn't really up on these things. So I got into it a little to see how deep his knowledge might be, to see if I could inform him of some stuff. I thought

he'd be interested about the backstage of our so-called democracy and the machinations of the faceless elites. This all came up as an extension of the conversation around Mark Stewart and The Maffia as this was that group's prime territory. I didn't want to berate, I just got some facts out in a sentence. Full stop. He looked at me from behind those eyes in the darkness of the back wall of the bar and just kept on looking. He didn't say nothing.

On one of the last times we hung out together in New York, Robin recommended I listen to Mobb Deep, a rap crew from some projects up on the West Side. They were seriously lyrical and serially tough. It was unlike him to recommend anything. 'Yeah,' I said, 'I do listen to them – all the time.' He looked at me straight and nodded. The conversation moved on. I didn't ask why he thought they were worth listening to. They were the sound of New York, the sound of the oppressed and the dispossessed and the sound of intelligence rising against the odds.

It stuck with me that he'd recommended them. He cared enough somehow to get me to tune into what he was digging and that felt good.

A final moment between us intrigued and affected me. He just told me he really liked Johanna and thought, 'She's a really nice girl'. It was lovely to hear him say this – just a subtle comment, but it seemed like he'd been thinking about it, waiting for the right moment to say it. Coming from him and his singular honesty about all things it gave confirmation to my own feelings for her and it perhaps made me all the more determined to be with her again, and for that I'm still grateful.

CHAPTER THREE

WEST IS BEST

I was gone, down Bolivia way and in the jungles of the Amazon for a while, flying over the Nazca lines in Peru and stopping off in Chile. I was interested to find out more about about the jungle vine psychedelic Ayahuasca but all of that is another story. I was free in mind, body and spirit but I missed Johanna terribly. She was waiting for me in Stockholm. I also came to an odd realization. I had started a lot to see Robin in my dreams, he had penetrated my mind so subtly and he was really there night after night, strong, determined, psychic, delivering up endless antics. That guy sure is real, I thought, over morning coca-leaf tea. He's super-fucking real.

One dream of many: I'm in a darkened room with Robin and a paranoid feeling resounds. The light is low. There is a large book between us. He has created a complete dictionary, full of pictures and reams of text, to replace

our conventional ones. This new dictionary transforms our language and perceptions, it's intended to seep into our conscious minds. It's aesthetic is revolutionary, to replace our common interpretations. I hold this book and flip through its pages in a fervour, the text flies off the pages, along with the images, floating transparently in the gloom around us. A fire burns in a grate, I can hear it crackling and feel its warmth. A desk holds the weight of this tome, a modern Book of Kells and its meanings absorb my mind's eye.

Yet, we are being pursued by shadows. Dark forces are approaching while the wind whistles up. We move off, this way and that, I'm swiftly following him. We both board a small aircraft which Robin knows how to fly and we glide up and out, north, above the West Country, over Cotswold valleys, with villages of honey-stone and ancient steeples. The people peacefully sleep in their beds. 'Ah, my beloved valleys,' I murmur. It's darkening and the landscape looms up at us, the hills

rise to meet our aircraft as we fly low, Robin's presence cocooned safely in the cockpit. Alighting next to an ancient Saxon church lying deep in the fold of hills we step out into a dust of frost that lies all about us. Stars glint in a moonless heaven, pulsing from above. We carry the book into the sacred building, uplifting a central flagstone near the altar and place the book in its hiding place for now, it being wrapped in patterned azure silk. I feel old England protecting its own.

I had been back in Europe for a time, stopping in England before spending several months in Stockholm with Johanna. The New York period was over and I had a longing to be in England as it was some years since I'd been there for any length of time. So I left Scandinavia to re-establish myself in Bristol and be closer to my family and to reacquaint myself with friends up and down the country.

It was a little odd to be back in Bristol, so much had happened there in the past, but I hooked up with some old faces and got some work in nightclubs doing doors and had a few daytime gigs around and about. I sorted out a nice place to live up in Kingsdown, looking over the city and Johanna flew in regularly to keep me company.

It so happened that I ended up in the Bristol Royal Infirmary in the summertime for a spell after swimming in the River Avon near Bath. Every chance I got I was out into the countryside on the Harley I had shipped over from the US and we had been out for a dip when I must have swallowed some water polluted with rat piss and I succumbed to Weil's Disease and was laid up in hospital recovering.

The day I finally felt better Johanna was visiting and she was anxious to get me out of the hospital. It was a glorious summer's day, and it just happened to be the weekend of the Ashton Court Festival. Ashton Court

Festival had been a free festival since the hippy days and took place annually up in the grounds of an old stately manor on the south side of the River Avon. I had been going there for years – it was a guaranteed good time, with a lot of great music being performed. Half of the city would be up there, so you were bound to run into friend and foe alike.

Johanna and I held hands and made a beeline for the place. It was quite a walk and when we got there I remember being sick and heaving up the hospital breakfast. Nevertheless, we continued into the main stage and got caught up in the infectious buzz of happy people and good music. I was pretty pale according to Johanna so I didn't think of heading for the beer tent, although a refreshing cider would have gone down well, perhaps.

The sun was blazing, the music blaring, we were just milling about and I was crowd-spotting, recognizing faces and saying hello

to some. Then I saw Robin standing on his own, the crowd moving around him. He was sort of looking at the ground, motionless. It was slightly odd to catch sight of him again in such a different environment to New York. I was really pleased to see him and I tugged Johanna's sleeve and said, 'Look, there's Robin!' 'Yeah,' she said, 'let's go and say hello.' We were twenty or thirty yards away and we moved towards him through the crowd. I actually stopped to observe him a little more closely as we approached. He was still just looking at the ground, occasionally glancing about. I was imagining some great reunion. I had been wondering about him, but seeing him, I began to get slightly nervous. Something was amiss. 'He looks kind of fucked-up, somehow,' I said to Johanna. 'Let's go up and say hi anyway.'

So we did. 'Hey, Robin, how're you doing?' I said as we approached him. He looked up as he was rolling a cigarette: 'Fucking hell!' he said. 'Are you all right?' I asked. 'Yeah,

yeah,' he said. I took a good long look at him. I could smell the cider. I figured he'd been on the apple juice pretty heavily. We said a few words but he was non-committal and swaying ever so slightly. I was beaming at him; I was so happy to see him again after all these months but he didn't seem to give much of a damn about seeing me. So, I said: 'How is it, being back in Bristol?' And he replied: 'The only thing wrong with this town is you and your fucking family.'

I couldn't believe what I was hearing and Johanna stepped back a little. I wasn't in the mood for this and could see he'd been on the scrumpy so gave him a wide berth. If you've been brought up in the West Country you would know very well what it's like to be trashed on rough cider, or 'scrumpy', and it can turn you pretty psycho – especially in the hot sun.

But his comment was out of order, deliberately so. It was a challenge: Stand up to me or fuck off. I wasn't about to creep

off anywhere so I looked at him with some sympathy for his state and said: 'What the fuck are you on about? You've never even met my family.' I continued looking at him and he looked up at me. I said, 'It's only three o'clock and you're fucking trashed.' 'Yeah?' he said; 'Fucking right,' I replied. Something happened then: that invisible click and we were right as rain again.

I asked Johanna to give me a moment alone with him and she moved off, quite puzzled by this 'English' episode, and we started to talk. He was arseholed on the rough cider.

When I look back at it now this exchange tells me two things. It was classic Banksy 'fuck off' humour – like, if you can't get beyond my razor blades, then fuck off. And secondly it was a classic risible West Country welcome. And that was it, we were back in cider country and you may as well behave like it! So, now, instead of wanting to punch his lights out when I remember it

I laugh my socks off. It couldn't have been a better meeting.

We spoke about a few things, of South America, of Sweden, of what he'd been up to, not that he'd remember anything that was said. He told me where he lived, asked me to come by and then he said 'Come on, let's listen to some good music.' And he led the way right into the pit of the crowd in front of the main stage. Johanna joined us and Portishead opened up their set to a rapturous, thundering crowd. The West is best.

Summertime was unrolling itself over the city of Bristol when one day I found myself walking down the old Welsh Back, a long-since redundant harbour lying near Bristol Bridge in the city centre. From a couple of hundred yards away, I saw a lone figure next to a wall of an old warehouse. I knew the building and the last time I had seen it, it was its usual red-bricked self. Now a volume of colour emanated off it. There was no one else about and I stopped

to survey the scene. I walked on a little more and the figure, which was silhouetted against the wall and was clearly in no hurry whatsoever, reached for a spray-can and employed a few stokes. Now I could see who it actually was. Robin. The artful dodger. I approached cautiously, not wanting to disturb him and also remembering our last hairy encounter. I walked up and took in his work; it was relatively similar to his New York cartoon stuff on the walls of the hotel. It was like this: a figure sitting in an armchair being blasted by a hubristic TV set, the piece was full of characters coming out of the TV and the tag line was, 'There's a lot of noise going on but you ain't saying anything!' It ran about four metres long by three metres high – a big piece. He didn't hear me coming and I didn't want him to think I was sneaking up on him so I said: 'Oi!' and kicked a can towards him. He looked around casually and his eyes brightened when he saw me. That was a good

sign and we started to talk and although he was surprised to see me he didn't miss a beat in his friendliness. I talked about this painting he was doing in broad daylight. He must have had permission to do it judging by the time of day. He was easy-going and after a while he got back to the wall, spray-can in hand.

It was time for me to move on too, but I was pleased by this unexpected meeting. When I said, 'Well, see ya,' he said, 'Yeah, come around to mine. Pay a visit.' We exchanged glances as I replied, 'Yeah, will do.'

I was often in Stockholm for periods and then back to Bristol. I know my town really well and have walked the neighbourhood streets endlessly. There was nowhere I wouldn't walk or cycle, day or night. I would notice any new graffiti as it was thrown up. I was always reading the writing on the wall. Some of the writers I knew personally – they varied from political sloganeers to Bronx

idealists. They reflected the state of play on the pavement, never lightly and often acutely. (It bodes well to know whose gang territory you happen to be passing through.) Suddenly I began to notice some eclectic stencils appearing. They were all over town, from Easton to Clifton, and they were eye-catching, humorous and challenging. Their number increased, but there was no tag, just the image. When you see this kind of quality about it makes you realize there is intelligence out there and that's reassuring. It also makes me proud of my town. It was just the kind of thing I loved to see on our walls as opposed to mindless, often sinister, corporate advertising on billboards.

I finally got round to visiting Robin's place which was between St Paul's and Easton. It was dark and rainy, the light shone out of the dampness and puddles. I hadn't bothered to call, I just showed up and knocked on the door. He answered and let me in, seemingly glad to see me. One or two

people were hanging out, relaxing, so we had a cup of tea amid the mess that was strewn around and I sat on an old, battered couch that had seen better days. He introduced me and I recognized the nicknames from around town. We spoke about events and happenings and some other personal stuff that was going on. Robin was very genial and I sat back, soaking up the creative atmosphere that rang from the walls and the sundry articles that littered the room.

I always felt good around people like him, someone who is doing their own thing with their own mind, and letting the world hang. The lights were low and I started to pick some things out, some canvasses, paints, loads of spray-cans and materials, like hardboard, metal and cardboard, with images or paint on. There was a big table pushed up against the window with the curtains closed (the street was right in front) and on it was a lot of stuff pushed into piles and bundles here and there, but on the space

that was left was a cut-out stencil about a yard square, perhaps, and cut into this cardboard was one of the images I had seen on walls all over the city. 'Fucking hell!' I said in surprise. 'This is you. I've been seeing this all over town!' I laughed and looked at him.

'Yeah, I've been doing stencils, have a look at these,' he said, and he produced three or four others, each of outstanding quality. He started to cut a new one and explained his technique and how the edges of the cutting had to be very clean so that when the paint was sprayed on the final image was finely lined. I was psyched out to realize that it was his work I had been noticing. I hadn't twigged that it could have been him – but now it made perfect sense. It could only have been him and I took a thrill from discovering his latest progression.

He explained his motives behind using the medium, its quickness, ease of transport and maximum effect. He bent my ear about it a little, like he was sharing his pleasure about

developing this new approach and pleased to find someone excited about it too and then he fell back to his characteristic reticence as he carried on cutting this new image.

I just watched him, sipping the tea. 'Fucking right on,' I thought. 'I'm lucky enough to see this young man develop his ideas and talent' – and his message was unique, hard and revolutionary. He was out there, in those quiet hours, applying his mind to the walls for all to see. It was burning in him, this art, and it was a cool thing to be around that single-mindedness, that energy. I just had to watch him, to keep tabs on him so as to see what he'd do next. The friendship was re-established. He had my 'Summa cum laude', that's all I knew.

I went to visit Robin on a semi-regular basis, when I was passing through his neck of the woods. We would talk a bit and I'd watch him do whatever he was up to with his art. One day he mentioned 'Delge' aka

'3D' from Massive Attack – the Bristol band that originated from the Wild Bunch crew – and how a classic piece of graffiti that 3D had done had been erased by Bristol council. Robin was offended by the incident and the ignorance of the law. He was right in that respect. I knew this piece from years ago and it was a well-executed New York-inspired wall work around Upper Byron Place. I was upset that it had gone too. 'But hey, that's the name of the game, that's what makes graffiti so righteous that it can be there today and gone tomorrow. It's illegal, it's a threat and the dark forces don't like threats,' I said.

In return for this statement I got one of those brow-beating looks and a silence, but it was almost like he hadn't considered that viewpoint either, like his work had a god-given right to be up there. My statement may have sounded obvious, but his single-minded approach to his art and all street art – the time he put into it and the passion, meant that the very idea that some ignoramus could

come and take it off the wall was absolute anathema. This isn't a perfect world. That good art can be taken off a wall by a bloke on minimum wage should get anyone's gall going but the forces of ignorance are strong. The irony is that now in Bristol when a Banksy appears the council doesn't touch it out of deference to the city folk who have taken him into their hearts. They don't really want another Bristol riot.

He also started to talk about Massive Attack and how he was hanging out with them when they were recording their classic album 'Mezzanine'. I had this idea about him that he was such a loner, such a masked man that he didn't really have too many established connections in Bristol, but I was wrong. It was clear that he was more deeply into the scene than me. I got the feeling he could take it or leave it but also that he felt it was only right that he should refer to and acknowledge those who had come before him and pioneered the trail. Also, it was

becoming obvious that his talents hadn't gone unrecognized: he was becoming known and increasingly well regarded. He had a certain individuality about him, a feeling of aloneness that surrounded him. It was always there. An outsider. A Camus. He would have been doing what he was doing regardless of whether people liked it or not. He was his own posse. One-man army. All that.

One day we were just meandering around a dog end of Easton, Barton Hill, taking in the neighbourhood, when he said, 'We're nearby the studio – do you want to come in?' He hadn't mentioned the studio before so I was intrigued and agreed. The place was so removed and unnoticeable it could have been in one of the industrial back streets of Brooklyn. You just wouldn't have known it was there if you were passing. It was a big place, splendidly industrial, beautifully light, and strongly built. It was the kind of building I loved and the kind the council

would knock down and place a high-rise on, or maybe an IKEA if the backhander was big enough. Imagine Brunel and his railway siding workshops.

We made our way in – through gates, yards, stairs and doors. No one else was there. I had thought that he was only using his living room for his creative space but this place was vast. A lot of his work was in one corner and other artists had stuff scattered around too. I was surprised to see quite large canvasses that were obviously his. There was a large table with stencils on it and a multitude of spray-cans, often foreign as the quality was superior to the British aerosol. The large canvasses held images of his I had not yet seen, of tanks with loudspeakers atop, of a rioter throwing a bunch of flowers, of helicopters with kissing lips and pink bows on top. He had been buying older classic works of art in frames to which he had added his own images, thereby morphing

them into a commentary on or antithesis of the original intention.

'What's that all about?' I asked pointing at an old countryside scene with yellow crime tape stretched around the trees (his addition, of course). 'That's about the way the television series *Crimestoppers* have made us all scared to even be in the countryside.' I didn't want to ask too much; he was tetchy around his art, as per usual. I looked at the helicopters with bows and lipstick on. 'I like that,' I said, pointing. 'Do you? I fucking hate that one,' he snapped.

CHAPTER FOUR

LONDON CALLING

Bristol is an eclectic and creative town. It's an ancient place, built on and rebuilt again after battles and bombs. The Knights Templar were big there during the Crusades. Cabot crossed the Atlantic around the same time as Columbus, funded by the Merchant Venturers of the city. Some of Bristol's history isn't pretty but some of its best-loved sons were poets, artists and musicians.

There's something in the Bristol water that loves the maverick, the independent thinker – the more advanced the better. The city's hills resemble Rome or San Francisco and any son that has walked stoned immaculate through its many streets on a frost-bitten night with the moon on high will tell you it is the most bohemian of places.

Now, back in the late '60s and early '70s Bristol was down on its luck and you could buy beautiful Georgian and Victorian properties for a song – and members of the counter-culture from those days did just

that. The hippies flocked into the city and in some people's eyes it became England's answer to San Francisco. This open-minded generation had children, the sons and daughters of bohemia, and they spread their parents' ideals through punk and other counter-culture movements. I spent four years in San Francisco but I never met any hippies that matched the bizarre, exceptional freaks that Bristol housed. And learned with it. There were legendary parties that went on for days, and mixed up in this was a sizeable Rastafarian population in the '70s, that led to cross-pollination of culture bearing fruit the like of which had never been seen before. Don't take my word for it, look into it yourself. True Bristolians know it, like I said, there's something in the water.

The reason I mention all this background is because this is where Robin comes from. It's not nowhere-land. The city has its distinct neighbourhoods. We can't go into them all here but if you find yourself down

in St Werburgh's crossing to St Paul's and over to Easton you'll get a flavour of what I am trying to impart. The energy is stone-buzzed and taut. The walls bear witness to the artists' efforts of many years. The labyrinthine streets are easy to become lost in; if you know the turf you'll always be safe, always be able to evade the officers.

Robin lived down that way, practised his art down there and knew the people that associated there. Easton, perhaps above all, is home to an enviable ragtag collection of nutters, bohemians, dropouts and rogues. This was his milieu in those days, not that he didn't travel, but this is where it was going on.

One night I was invited to an evening of eccentric persuasion round at Robin's studio. He had invited me for supper. Candles and colours lit up the place like a scene from a Peter Greenaway film and surrounding the tables, on an odd assortment of old skip-

SEVEN YEARS WITH BANKSY

found chairs, couches and armchairs, sitting and standing, laughing and conversing, was a collection of the unorthodox free citizens of the local environs. The vibe was at fever pitch as people were just about to eat. Some of the people I knew and some I recognized but most were strangers to me. I had squatted over in Easton when I was a teenager and knew the locals back then but most of them had since died, been locked up or got the hell out. I was back in it tonight, I could tell; it was like I had never left. I had ridden over on the Harley and I had been telling Robin about it, so I collected him from the party as soon as I had walked in so I could show it off. I didn't think he would be impressed at all – in fact, I thought he may well not pay it any attention, but I was proud of it and the fact that I had got it together to ship it back from New York, so I wanted him to see it. It was a mean beast, customized in a classic, timeless fashion.

On this moody night the chrome

gleamed through the fog. To me, it was like a living creature, ready to pounce, its personality was that strong. 'Fucking hell, yeah, I see what you mean. She's a beauty,' he enthused. He had a closer look and the clockwork in his brain took it all in. He looked up, he seemed to be smiling inside. 'Come on, let's go up,' he said and we got drawn back into the party.

His response to the motorcycle was like his take on Johanna – he liked it, and that gave it a deeper value for me. Maybe it was a weakness on my part but I wasn't seeking approval. It was affirmation that my judgement was right.

People had begun to eat; the wine, the beer and the spliff were in full sway and a more gregarious gathering of people you could not find. The conversation was ribald; the jokes explosive; the food good. I ate and sat and chatted and watched and observed some more. I had become endlessly observant on account of my travelling, and

although I loved parties I could also freeze myself out somewhat. So after sussing out the scene and the characters present, I took to looking at the art, especially now my head was expanded on account of the marijuana.

Robin's stuff was just so good, so simple and straight up in its execution its cadence just sung to me, like so many others would appreciate. I picked up a chunky piece of white laminated hardwood on which he had done a stencil – a picture of a bloodhound gang on the chase of a scent. I thought it was cool-as-fuck. It had been propped up by the window and I placed it back there. Just at that moment Robin came over on his own and just hung there.

'That's a cool piece,' I said. 'You want to sell it?'

'Mmmmmm – no, you can have it, it's nothing,' he said almost sheepishly.

'No, go on, I'll give you a tenner,' I insisted.

'Go on then,' he said.

So I fished out ten quid, which to me seemed like a fair amount of money.

'Thanks,' he said. 'I'll put it towards the food.' He paused and then said: 'That's the first painting I've ever sold.'

The words rang in my head as he moved off, but someone had seen the money change hands and a little coterie suddenly rounded on me. A self-appointed Scouse Nazarene was at the front. I had actually shared a house with him for a spell in the past.

'Rob, what are you... How could ya?' he said incredulously.

'What's the problem?' I said.

'You bought that off him didn't you?'

'Yeah?'

I had crossed some line with them, some unspeakable, invisible code had been broken. There weren't any more words said. They just looked at the Judas. 'Fuck them,' I thought, and left soon after, belting down some moody, neon-lit backstreets on the motorcycle just for the hell of it.

Robin was going up to London a fair amount so every now and again he was gone from Bristol and would then reappear. Gradually his stays away were becoming more frequent so we arranged to hook up while I was visiting friends up there. I used to live in the smoke in the early '80s and had kept some friends with whom I used to catch up from time to time.

It was 1999 and there was that apprehensive 'end of millennium' buzz in the air. It was always a laugh to be in London, and I used a lot of my time up there to explore its hidden corners. I'd always enjoyed getting down to the old industrial remains of Wapping and its warehouses, Rotherhithe, Millwall, the Isle of Dogs, and splendid Greenwich, so I was intrigued to see the changes since I had been away. I was pretty horrified by the Docklands renaissance, the decay of the past had been hastened away along with its romance and it had become a gentrified stink of a place.

The Docklands Light Railway took you on a tour of the new capitalist palaces and towers, the old quays lined with generic dwelling places of corporate minions. How crap it was, how soullessly boring in contrast with the old dockers' culture and haunts. Nevertheless, I was curious to have a look at the construction of the much-hyped Millennium Dome, and there was Norman Foster's state-of-the-art tube station to check out too. Robin wanted to see what was going on down there so I arranged to meet him and a couple of my London mates as they hadn't yet been to see the mess.

One was called Kes, the other, Jesse, both of whom I used to work with. I had been looking around the tube station with Kes for a while, which was refreshingly awesome – and we were to meet Jesse and Robin outside on the plaza at a certain time. Robin hadn't met these two friends of mine before. Kes was now a fireman and looked pretty hard with close-cropped hair (as was

his taste). Jesse looked relatively harmless by comparison. So we were just hanging out there waiting for Robin to show, which he didn't do; at the appointed hour we waited and talked a little and waited some more. Then we were getting hungry. My friends were starting to get bored and I had to coax them to stay, explaining that this bloke Robin was actually a pretty interesting character and that they should meet him. I started to despair a little and began clock-watching, feeling like a mug, when suddenly I caught some movement out of the corner of my eye. The place was quite wide open and I had been expecting him to emerge from the bowels of the underground but I was scanning 360 degrees anyway. And then from the same corner I saw movement again. 'That was him, I'm sure,' I thought, picking out a glimpse of his features.

He was about a hundred yards away but he disappeared again. 'What the fuck is he playing at?' I said out loud. 'What?' they both

chimed in. He was sizing up my two mates in case it was a big set up – or something.

This was becoming amusing, but daft. All of a sudden, he just popped out from behind a close-by pillar. 'All right then?' Robin said as he shuffled his feet in front of us and we were all a little taken aback. How he had got from the first place I saw him to appear from behind the pillar I do not know because I was looking about the whole time. He was here and he seemed a little nervous so I tried to put him at ease and introduced him to the chaps who were, by now, regarding him with mild amusement.

We started talking and Robin relaxed. However, it taught me again about how careful he is around people he doesn't know; how seriously he takes his liberty and how trust with him was a rare thing – and if you had that trust, even a little bit, it was hard won. By now it was obvious he did have a tag on his tail. He was known and if a copper could take him in for all his graffiti it would

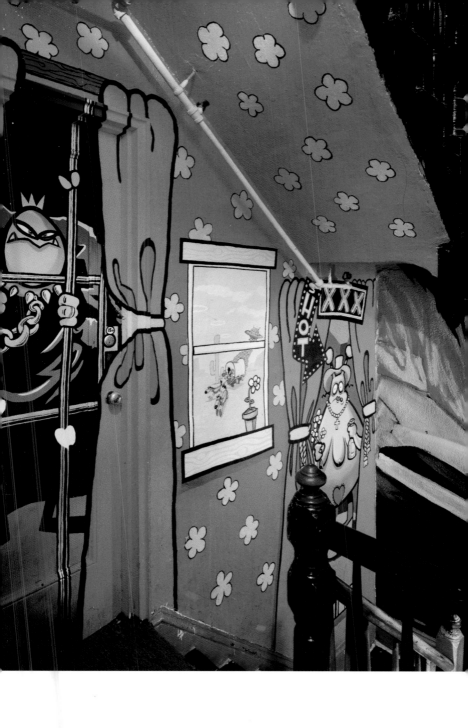

Banksy´s foyer at the Carlton Arms in New York.

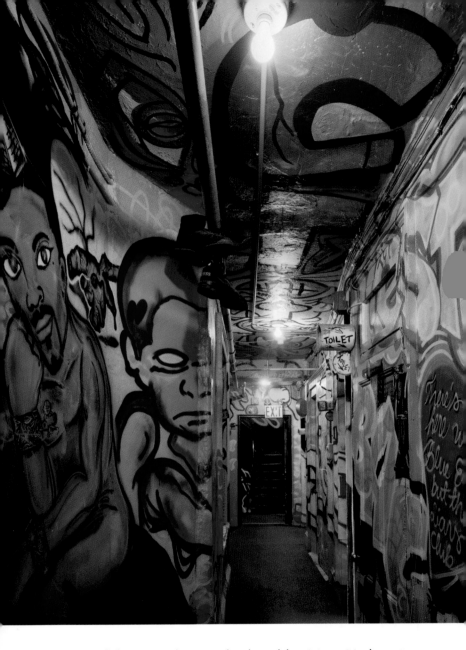

One of the corridors at the hotel by New York artist
Andre Charles.

The Williamsburg Bridge
rising to meet the city: my way to work

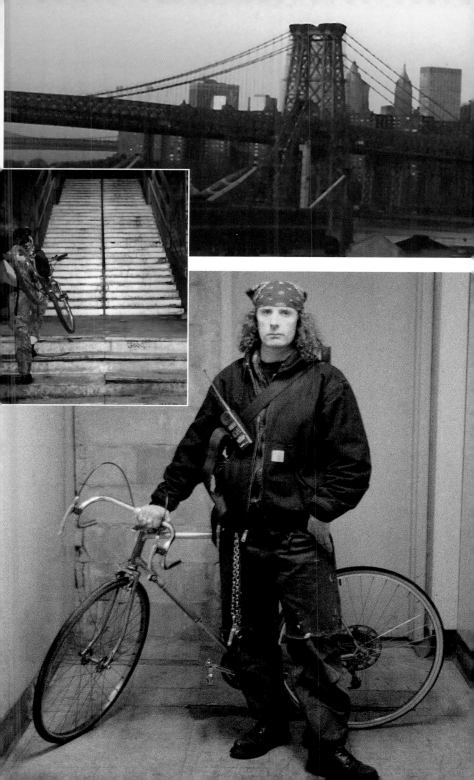

Banksy working on his piece at the graffiti festival he organized in Bristol. His tag is in an operating theatre being dissected by surgeons and watched over by suited spooks.

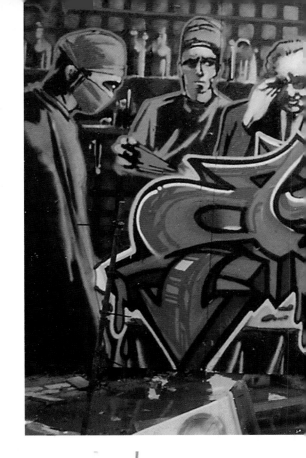

More from the graffiti festival Banksy organized.

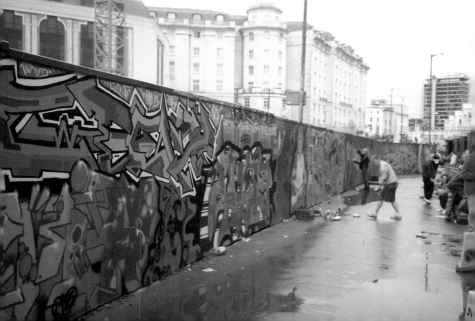

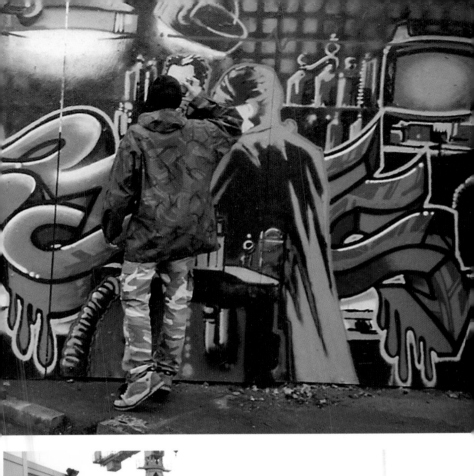

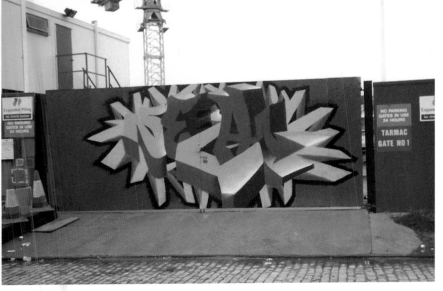

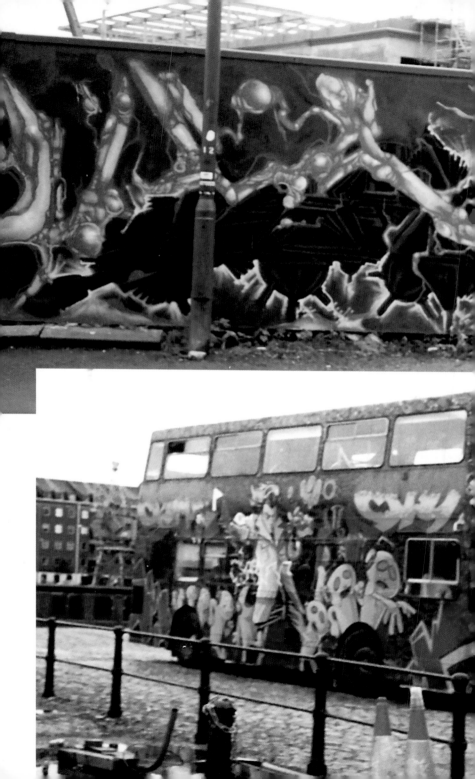

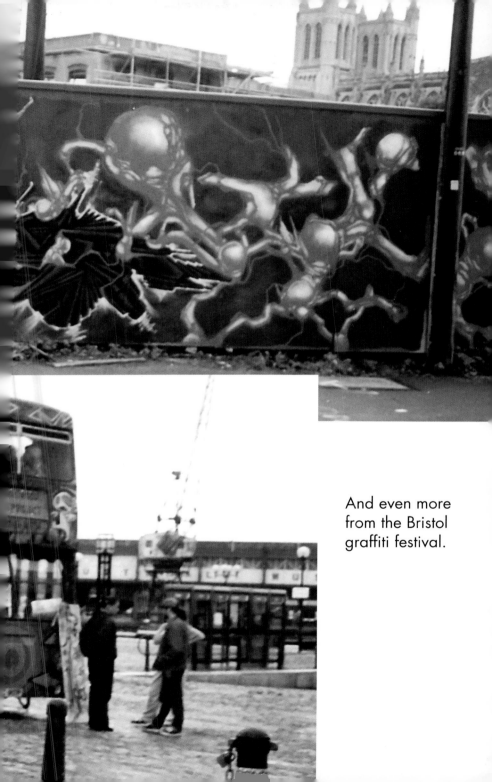

And even more from the Bristol graffiti festival.

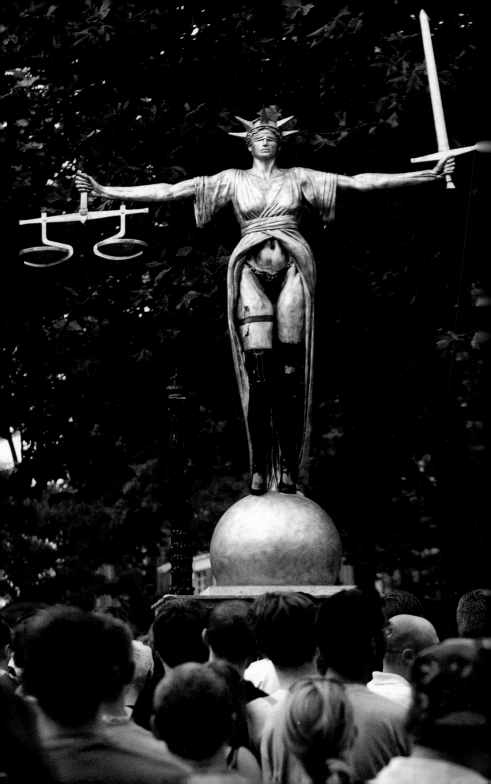

Banksy's signature on the first picture he ever sold.

His first city installation, Liberty becomes a prostitute.

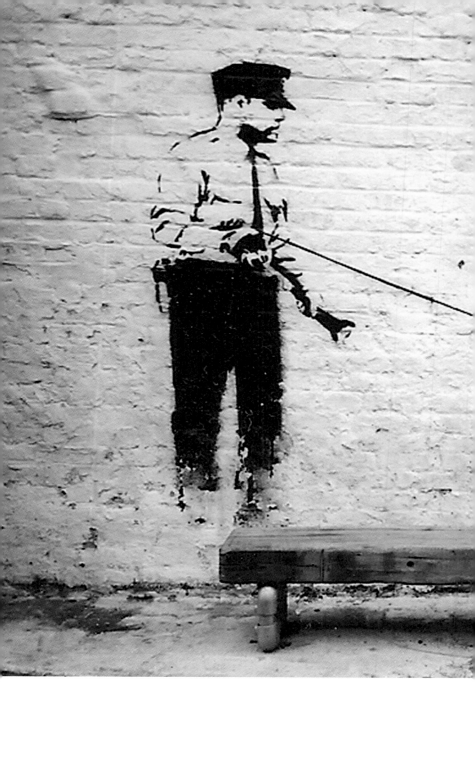

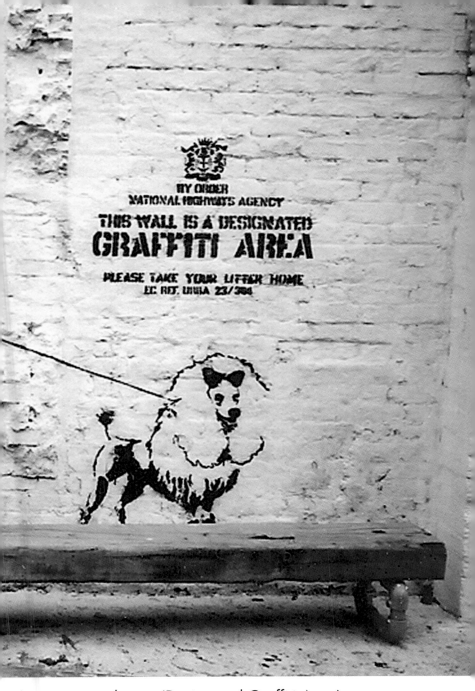

A not-yet-acted-upon 'Designated Graffiti Area'.
Official-looking emblem from a fag packet.
Note – 'Please take your litter home.'

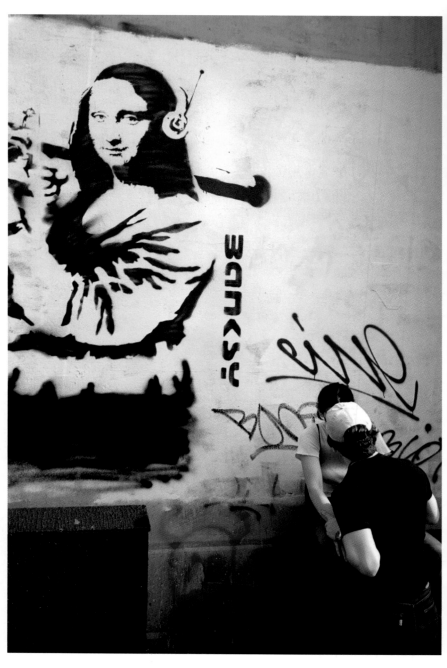

Mona Lisa carrying a bazooka first seen by me
in the middle of a riot.

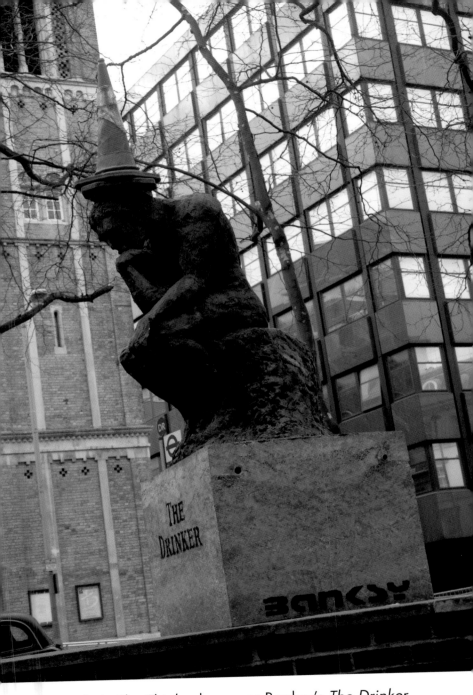

Rodin's *The Thinker* becomes Banksy's *The Drinker*, commissioned and plonked down at his own expense in a London square.

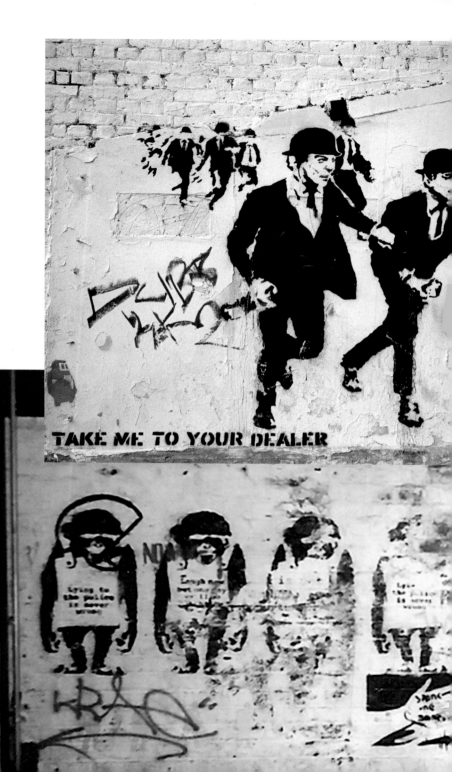

TAKE ME TO YOUR DEALER

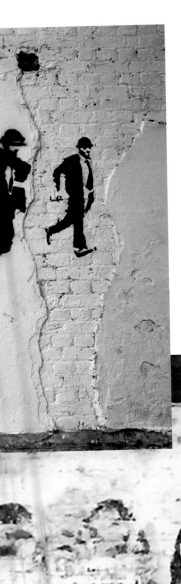

'Never been in a riot'.
City gents having a go.

Banksy's monkeys –
a recurring motif.

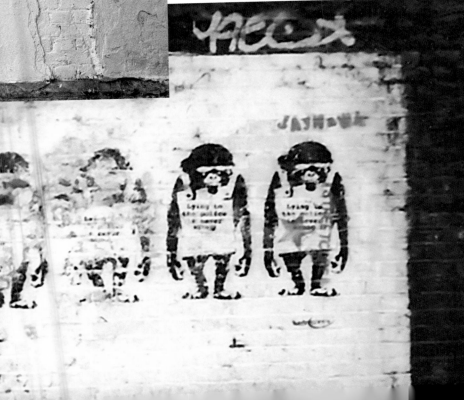

West Country
= Cider.

be a very serious business. But still, the image of him checking us out and dodging behind walls and pillars before he made his mind up to meet us that day still makes my ribs tickle.

As it happened, Jesse and Kes had things to do, so they left shortly after, leaving the two of us alone in the square. I looked at him enquiringly but he didn't offer an explanation, as if his behaviour hadn't happened.

'Let's have a look at the Dome, or what?' I said, and we trotted off through this brave new landscape to view this corporate wonder. It was a big site and obviously we couldn't walk in past security but it had fences, which you could see through all around its periphery. The white Dome was actually up and it was quite an impressive sight. There was a lot going on: earth movers, lorries and workers. They paid us no attention as we circumnavigated, as best we could, the whole place. We ended up by

the waterfront looking over towards the new buildings of the World Trade Centre, then over at Canning Town on the north side of the Thames.

Robin was pretty distant and I could tell the cogs in his brain were whirring.

'What do you think then?' I asked.

'I've got a few ideas,' he replied. I never did know if he carried out an art attack on the Dome and its surroundings. I haven't been down there since. The new architecture creates very exposed spaces so get-away plans are limited.

Every time I was in London I would hook up with Robin. I was moving mostly between Stockholm and Bristol but also felt a pressing need to get up to the capital as often as I could. By this time he was mostly living there and things were starting to happen for him. As a side effect of his bombing campaigns, in which he would litter neighbourhood after neighbourhood with his judicious work, he was getting

known. I was personally amazed at his all-town obliteration. His art was getting bigger and bolder. Shoreditch walls and Brick Lane bridges, Soho for its centrality, Camden, Notting Hill and several other places all had his signatory efforts.

He never once told me about what he'd been up to, never pointed out a new piece. I just came across them as I moved around – and I didn't even live there, so the spread of his work was obviously much wider than I could ever take in. And all this as his work in Bristol was increasing too. He was becoming notorious. Some of the locations were breathtaking like his 'Wrong War' on high bridges. How did he get up there? How did he remain unseen? He was outrageous, he was everywhere, like a nocturnal tomcat on the prowl. He saw the city's ripped backsides at an hour of night that not many of us are privy to.

The remarkable aspect is that it all seemed effortless. Whenever I saw him

he was just the same as always, admitting nothing, releasing nothing, just composed. I made a comment that he had hit the ground running in London, that I'd seen his stuff all over. He didn't even respond. He was totally unconcerned. He was just doing it. Full on, non-stop, rocking-the-block. Rising again and again.

I was on one of several anti-globalization demos in the wake of the riots in Seattle around this time. The police were trying to kettle us in Oxford Circus and a group of us managed to break away and move south, pursued by the coppers – who were on horseback, on foot, in their riot wagons and in a couple of helicopters. They chased us to Broadwick Street in Soho, where the inevitable face-off ensued. The tension was high and the coppers in body armour, shields up, truncheons raised, moved in. Then boom! In the corner of my eye I saw 'Mona Lisa Wielding A Bazooka' straight in front of us, the size of the back of a bus. It

was a Banksy, of course, and it lent such an inspirational uplift to the proceedings that I felt his art had become the very soul of the city, empowering us with its intelligence and liberty and encouraging us onwards. We got the fuck out of there, like slippery eels, and later that night I went back to that spot just to relive the moment, to look at his art on my own. It blew me away and I was all the more inspired because I knew him.

The next time I saw him I told him of the piece of theatre that had taken place and the effect of his Mona Lisa on the proceedings. I think he smiled at that – it was high praise indeed.

Sometimes when I saw him in London we would just wander without any destination in mind. Just me and him, no rhyme, no reason. And it was in these quiet moments that he would explain his latest ideas to me. I would just listen. It wasn't that he ever asked for a response and all I could express really was my interest in whether it sounded good

or not. As we wandered I remember him telling me that he was going to commission a sculpture of Liberty and her scales, wearing stockings and suspenders, as a prostitute that could be bought, and that he was going to have it raised in a public square somewhere in London.

I acknowledged the idea but was foolish enough to assume it would never happen. I just thought he was getting ahead of himself. His thoughts were always on full tilt. The money it would cost, et cetera, seemed too far-fetched and I asked him about this but he said he was going to put every penny he had into it. He was so into his plans for bigger things, bigger statements, that I kept quiet, in case he didn't achieve them. But how wrong I was. I wasn't there when he raised his Statue of Liberty in Clerkenwell, maybe I didn't deserve to be either. Oh me of little faith! He bowled me over with his conviction, having the wherewithal to carry this project entirely at his own expense.

He never gave me the impression of having much money; his clothes weren't extravagant, we never ate when we met, he was skinny. Every penny went to further his vision. I was just lucky to hear about some of these plans. But I could see he was fulminating on his course. He'd only just started doing work that wasn't graffiti. His energy was definite and careering, naturally emanating. He was on an upward curve, God-given and righteous.

Similarly, when we were walking past the impressive statue of Boadicea and her chariot outside the Houses of Parliament he just said casually, 'I'm going to put a wheel clamp on that.' And later, he did. The image of this British warrior being stopped in her tracks by petty officialdom is so him, irony for the masses. And, then again, he had this idea: 'You know how students always put a traffic cone on the heads of statues on a Saturday night when they're pissed? Well I'm going to get Rodin's *'The Thinker'* cast,

full sized, with a bollard on his head.' And we would just jog on whilst the City polluted us. Silence falling again between us.

Sure enough it was done – on Shaftsbury Avenue! It was huge and weighed tons and would have cost an arm and a leg to commission and he needed a truck and a crane just to plonk it there. It's incredible that he believed in this so much that he would cough up all his hard-earned cash just to have the satisfaction of bugging-out the passers-by on their way to work the next day. For the city to remove them also raised questions: 'Who put this here?' 'What are we going to do with it?' 'Move it?' 'Where to?' 'How can someone just set down a huge sculpture and inflict on us their humour?'

I was wondering about where he was getting money to carry out these guerrilla operations in such an audacious fashion. He didn't seem to be holding down a job. I didn't ask; but one afternoon as we were

walking up Wardour Street he went into a record shop and said he just had to pick up something. The guys behind the counter knew him and chatted and handed over to him some money while I noticed his work on T-Shirts which they were obviously selling. And then, later, we were hanging out down Westbourne Grove. When we were just about to part company. 'So what're you gonna be doing then?' I enquired.

'Ah, I got some work on – for a record label. I'm gonna do Blur's record cover for their next release.'

'All right' I say and nod. If he was in there he was in all over I figured and besides the earnings he was getting connected to another world well outside of Bristol. He wasn't going to stop moving up. London had him now, beyond the parochial confines of the West's capital. I felt a little sadness at this realization but could only wish him on, usher him forward (not like he needed it) but as our friendship went through its paces

I felt for the first time that he was on an upward spiral of his own making that would make him international, that Bristol would be robbed of him. It is hardly a betrayal and he's never forgotten the City – far from it.

After we parted that day I headed down to see some architect friends who had an office in a large communal warehouse space near the Westway. As I walked in the main area, which was the size of a tennis court, I casually looked up and bang! On the main wall was a large canvas displaying a rioter, arms outstretched, preparing to throw flowers. The iconic image I had seen at the studio in Easton. This was one and the same. Sold. 'Shit! He's London's now,' I muttered as I headed for the stairs and regarded this familiar piece from the balcony.

CHAPTER FOUR: LONDON CALLING

CHAPTER FIVE

MIDSUMMER

I was just doing my own thing – running here and there, helping to run clubs and what-have-you; running about in various guises; spending time in Europe when funds would allow and getting onwards and upwards as much as the world at large would let me. I came to realize that I had encountered and befriended one exceptional person in Banksy. We kept in touch and I always liked to see him but I could feel this other force pulling him in a certain direction. He was headed somewhere I wouldn't be going.

There was an independent bookshop called Greenleaf on a street called Park Row in Bristol, that is sadly now defunct, and was run by some rather nice ladies. They kept an excellent stock of books and periodicals and I was often in there, looking at something, purchasing something. I was cycling past one day and saw that a few prints had been displayed in the window and they were for sale. They were some of Robin's stencil works, in colour no less, but they were

pieces you could see just yards away in any direction on the walls. It was the first time I had seen any prints of his for sale and they were signed and numbered. They looked good but did not have the impact that they had out on the street. Still, there was one of my favourites – 'Bombing Middle England' – a stencil of proper English ladies practising the refined sport of bowls. All clad in white as befits the civilized game, only the bowls were bombs. The prints were not expensive, maybe twenty or thirty pounds, so I snapped one up even though my cash flow had become severely limited of late. I stuck the print up in my hall with a few thumbtacks.

I told my family and friends that this guy's prints were on sale and that they should go and get one before they all flew out the door. My mum was about the only one who thought they might be worth buying. Most people were too strapped paying the bloody council tax to even bother considering it. Can't say I didn't try.

Perhaps six months later they were selling another selection of two prints and I gazed at them from the pavement unable to buy one before they were all gone. By now I was done-in financially too. Sure as hell should have bought one but that would have meant going hungry. Oh well. The price was minuscule in comparison to what one of those prints would go for now.

It wasn't long after that his first ever exhibition was to be shown down in the old docks in what was then a new restaurant, the 'Severnshed', an old industrial shed transformed into an eating establishment. I mentioned it to my brother and a few other mates and we got down there on the opening night. Robin hadn't told me about this event and, of course, he wasn't going to be present there either. We walked into the pretty swish surroundings, all bright, new and expensive-looking, juxtaposed to the gritty streets around it. This is about the time that

people started getting a bit precious about Robin leaving his roots, beginning to sell out and all that. I probably felt a little that way myself but put that out of my mind to take in his new framed works. They ranged from little to large and they all looked good. A lot of it was new stuff I hadn't seen and I was suitably impressed.

The crowd was pretty sparse. Quite a few Eastonians were there, milling about, appreciative but a bit sniffy about their ownership of this young man. There were others, more moneyed, more clueless, the ones who had never actually seen a Banksy on a wall. And then there was us. All the pieces were for sale but they were more pricey than the works at the Greenleaf Bookshop. I think they started at perhaps forty pounds and went up into the hundreds. 'Fuck, we should buy one,' I said to my brother. But he didn't have any spare cash – same as me. I had another look round before we sat back on a couch, taking in the evening and looking

out over the water, watching as little sticky red dots were placed on each piece that was sold. It felt horrible to not have enough cash while they all went, one by one. We couldn't even afford a round at the bar. But what we did know was that this artist was one of us and that was reward enough; we could see all this stuff on our streets for free anyway, any time.

It was also the point when Robin's work started to become popular in a different way, with rich collectors, looking for an investment. They would buy a picture and then sit down to eat. We couldn't take much more so out we went and stood in the rain instead, silently.

It wasn't too long before Robin and I met up again, although I was more likely to see him in London than anywhere else. Things were continuing to happen for him up there and he was enforcing his carpet bombing campaign of all available public space from traffic bollards, to billboards, to bridges,

to walls, to signs, to pavement, to cars, to tunnels, to wheel clamps, to all available surfaces. He was becoming a fixture.

The newspapers were beginning to wonder who he was. He was never one to explain his activities or what he'd been up to but if something significant had occurred he would mention it. We were sitting somewhere in Central London when he told me this tale.

'I was out just the other night, setting up a stencil on the walls of the Telecom Tower. It was late and I had some mates sitting in a car next to the kerb. The paint was by the door of the car and I was just going to get it when out of nowhere the cops show up. One copper comes out with a sub-machine gun, you know the kind they carry at airports, and holding it cross-wise over his chest, you know how they do. The cop looks me up and down and asks what I'm doing and he looks at the car and at the paint, and then at my mates inside the car.'

'Shit!' I said, 'What did you say?'

'I said something about how we were moving the paint around in the car because it was in the way and by this point he's well suspicious and the cops in their car were running the registration through their records. I was sure he was going to notice the stencil taped to the wall, but he just kept looking at me. Then he turns to me and says: "You better be careful, I might shoot first and ask questions later." And he just stared at me. He was wired and nervous and he just kept looking at us while they were checking up on the registration, it went on for ages.'

I could imagine the face-off underneath the Telecom Tower, early in the morning, some traffic rushing past. Stencil hanging on the Telecom wall. If only the copper had twigged this was the underground legend 'Banksy' he would be on about it over his tea and biscuits for years to come. Robin was good at keeping his mouth shut and just seemed to play out the moment. It was

hardly his first encounter with coppers. He had run from many of them in many towns and usually got away. But this was a little different, a little snappy copper with a top-of-the-range sub-machine gun strapped on who 'might shoot first and ask questions later'. He continued, 'Eventually the copper got a signal from those in the car and he told us to fuck off.

'We drove off and I was mentally begging him to not look at the stencil on the wall. We took off and that was that. He just hadn't made the connection.'

'What happened to the stencil in the end?' I asked.

He looked up, almost surprised by the question. 'Oh, I went back a couple of nights later and sprayed it.' I cracked up completely. The tension of the story and then his brazen attitude had me reeling.

This story has got to be a perfect illustration of the boy's resolve, but the cop with the Heckler and Koch certainly

made an impression on him, for he was to mention that incident again on a number of occasions.

Summer was coming up and the West Country was a pleasant place to be. Bristol got even more laid back than usual and Somerset ('summers setting' to the ancient Britons) was gloriously fecund and its coasts cooling. Music festivals were in full flow, you could spend your entire summer moving between them. However there is one festival that every native of Bristol thinks they have a divine, ancient right to attend gratis, just courtesy of the fact that they were born and raised in this magical landscape. That festival is, of course, Glastonbury. Down in a valley, lost to England in normal days, near Shepton Mallet, on a farm that is relatively anonymous for most of the year, takes place a circus extravaganza that has beguiled hundreds of thousands since the early '70s.

I first spent an insane, tripped-out weekend there in 1978 and returned every

summer I happened to be in the UK. Even when I'm abroad, the summer solstice always tunes me into the magic of Glastonbury Festival. We all know the festival has changed with the advent of the circle of steel fencing that is supposed to be impenetrable, but when I first went there you could just wander into the fields where the festival took place and no one would challenge you in any way. I can still see the connection between the old times and the present day.

Now, Robin is a West Country lad and I'm sure he'd be the first to admit that if push came to shove, and although I hadn't seen him in a while, the festival would be de rigueur for him. Thus I had an inkling that we would bump into each other at this year's gathering. I arrived at the site a day before it was due to start and settled in. I was lucky enough to be crashing in the medical staff's field where one of my mates and my brother were involved in talking people down from paranoid or insane trips over the weekend.

So I was ambling round the proceedings, looking at everybody setting up when I saw the graffiti bus next to a huge hoarding. Someone was painting on that hoarding and it looked like Robin. And so it was. I strolled towards him, getting closer, and making out the details of his work. Nearby were four large individual letters as big as two-storey houses spelling out 'LOVE'. The sun was shining, the grass was green, the wind a little breezy. The valley side rose up in the distance and it struck me as incongruous to see him in this environment; out of the gritty city, his usual urban turf, but there he was, throwing up a vision of urban depravity and decay the size of a small hill that would be seen from all around.

I wandered up to him, stood there, looking up and he continued painting for a while longer then glanced down from his stepladder. 'Hey, all right?' he said carrying on with his painting and we talked for a while. He was so relaxed and into it, in

his element you could say, and I just hung around, watching his vision come through, watching the clouds rolling past, watching the grass grow with the Glastonbury Tor rising out of the end of the valley, glinting in the distance. Summer entered into me, and the fresh air was calming and serene. I felt the city falling from my shoulders. I was back in the countryside and it felt good.

I was up in London again later that summer with Robin and we were strolling along in the warm afternoon and he was chatting away about this and that. He would have ideas and I still hadn't learnt to take everything he said seriously. He was so full of them I thought it would be impossible to realize all of them. Some I commented on, others I was polite about and kept quiet so he wouldn't lose face if they were unachievable. I mean, that was my fault, to think that way because in reality nearly all he said he would do, he did. He was a man of his word. I never heard him boast, he would just sound off

CHAPTER FIVE: MIDSUMMER

about his complex plans and concepts and then, magically, they would be realized.

One idea he mentioned that day was the creation of public graffiti areas. 'Yeah, you know these boards that they put up around building sites, about nine feet tall, usually painted white? Well I'm going to turn them into public graffiti areas,' he said.

'Yeah, how?' I asked, intrigued by the concept.

'I'm going to just take an official working emblem, like off of a fag packet like this.' He fished out his cigarettes, pointed to the emblem on the top and continued. 'I'll invent the name of a government agency and just stencil up that it's a designated graffiti area. And then wait and see what happens.'

We kept on walking as I was imagining his idea in real life and marvelling at its simplicity. An idea that would inspire all the young hoods to do their thing all across town, thinking it was law-abiding to do so. It was just a subversive inversion of the power

of the state. A twist on normality that would inspire a rush of creativity and would piss off the powers that be at the same time. All I could do was laugh thinking about it. Robin seemed to be grinning too. His humour was irresistible but the prankster didn't really laugh at his own jokes.

When I went back to London a month or so later I had forgotten his idea. I was out walking and rounding a corner I just happened to come across a large, previously white wall entirely covered in graffiti, tags, and provocative images and statements. It was so completely bombed it was unusual. And it was no dark corner of the city either, it was a well-to-do neighbourhood. Why here? How come so out in the open? I crossed the road to have a clearer look and then, I saw an official-looking stencil with emblem and numerical ordnance code that proclaimed civilly that this was 'A Designated Graffiti Area'. It didn't say 'do your worst', naturally, but it communicated that very sentiment to

all young guns and they had indeed attacked the walls with admirable energy. I laughed out loud, and that I was privy to this idea previously cracked me up all the more. In my usual journeys through the capital I saw many more graffiti sites proclaimed as official by Mr Banks.

I imagined kids being arrested by the police as they painted, only to tell the good officer, 'But it's an official graffiti area!' and the cops having to let the little tykes go.

Banksy: 1 – Establishment: 0.

CHAPTER
SIX

MILLENNIUM

I had been gallivanting around, spending every spare penny on travelling to see Johanna in Stockholm, doing clubs, some building, some gardening, whatever I could pick up. The nights were drawing in, the millennium was fast approaching. I hadn't seen Robin for a stretch and I didn't expect to particularly. He was busy, moving in his circles and manifesting his plan for world domination.

Then one night, quite late, I was sloping up one of Bristol's hills, coming out of Montpelier into St Andrews. It was gloomy, wet and cold, you could hear the sound of trains from the main track nearby. The hazy light from street lamps reflected up at me dimly from the puddles on the pavement. I bumped into a gaggle of boys and young men moving solemnly and swiftly along the road. One of them was Robin. I'd never seen him with these people before but I knew one of them slightly. I immediately got the feeling that something was wrong. Robin

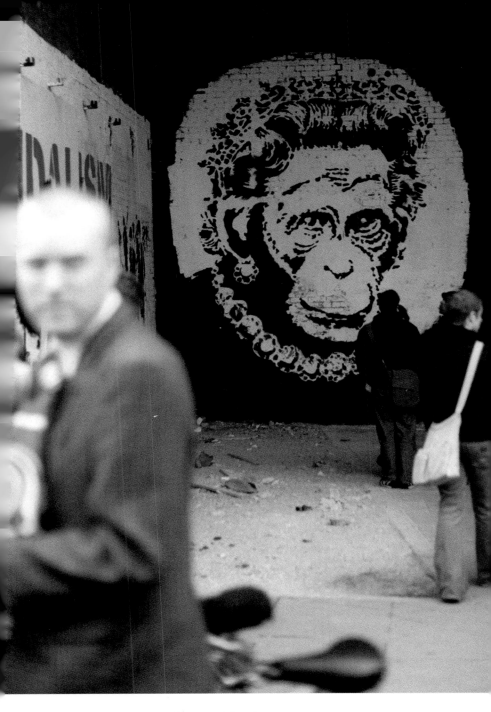

Queen Monkey.

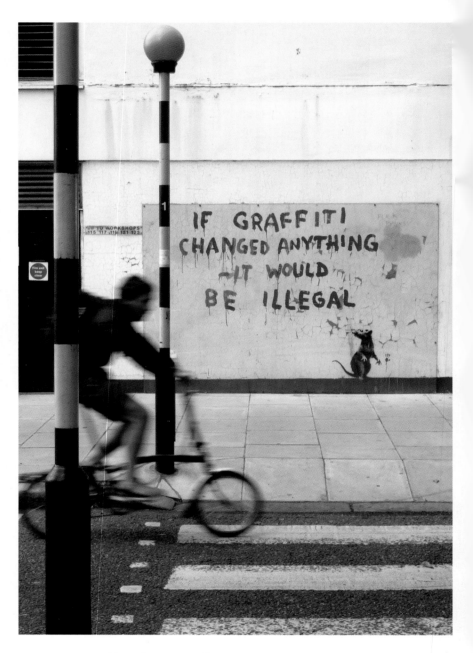

More graffiti about graffiti.

Typical dark humour.

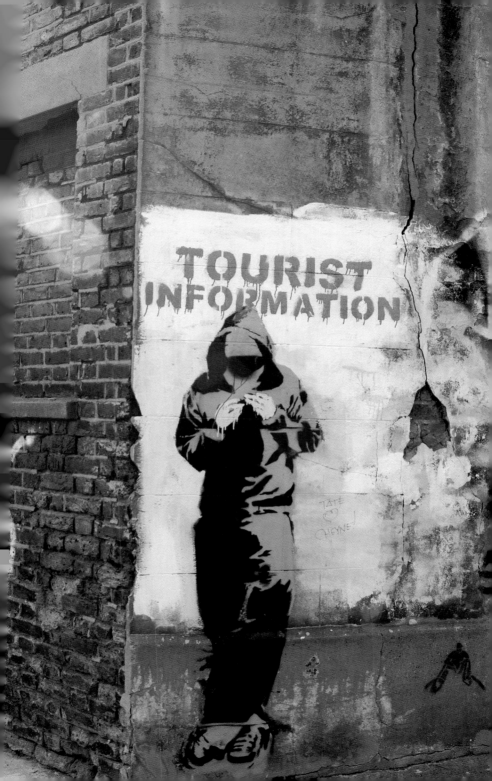

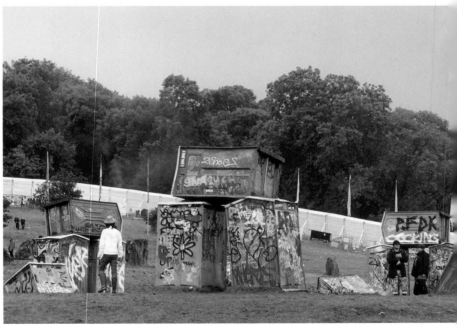

Banksy's Portaloo tribute to
Stonehenge at Glastonbury
before and after.

My Harley shipped back
from New York.

Another left-field idea
becomes a reality.

Playing with iconic images of London ...

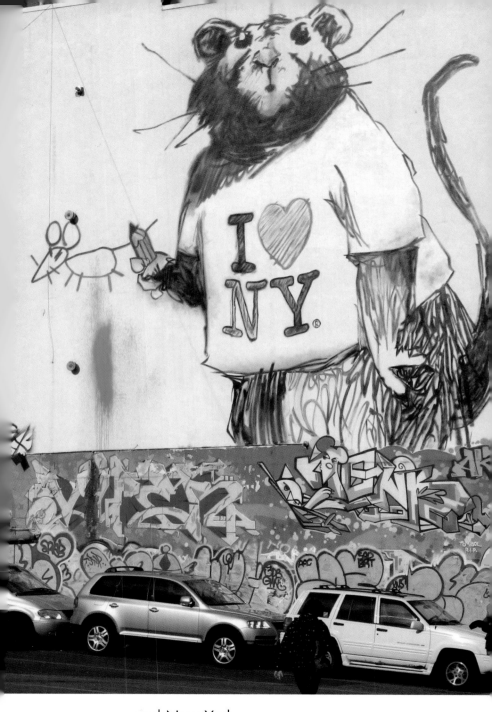

... and New York.

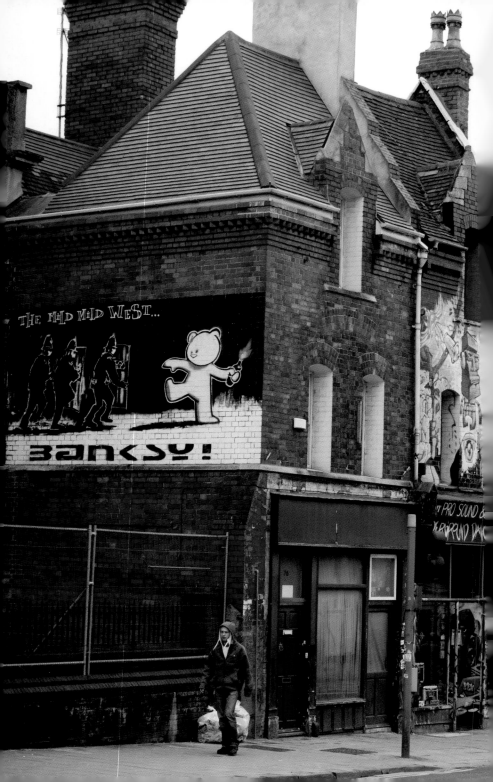

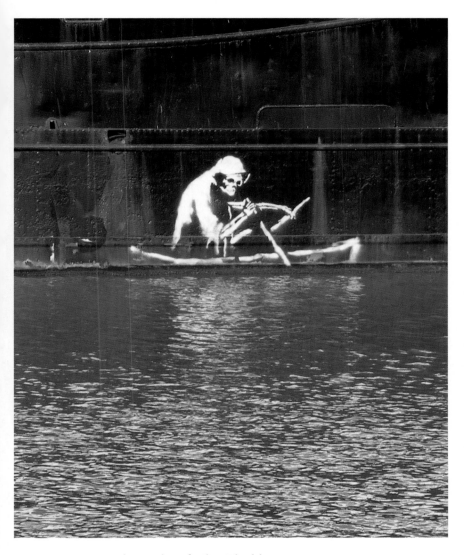

On the side of *The Thekla.*

Banksy in Stokes Croft, Bristol, later
defaced by disgruntled 'Banksy leads to
gentrification!' protestors.

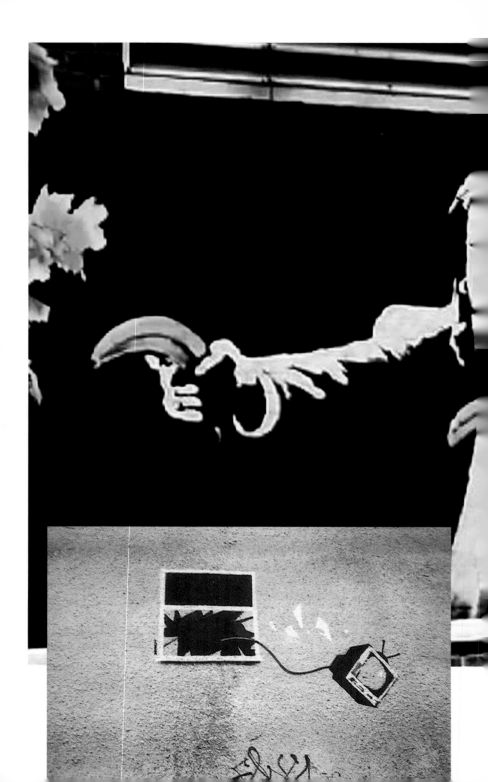

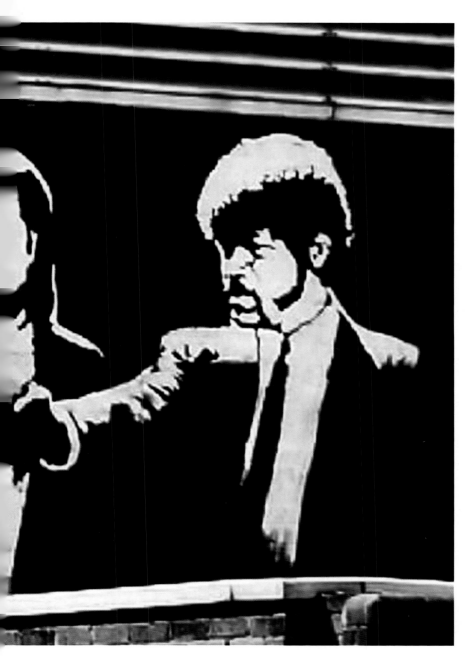

Classic take on *Pulp Fiction* in Shoreditch, London.

The revolution will not be televised.

Banksy graffiti in Manhattan.

Paradise Quarry, Somerset.

hardly acknowledged me, he had a backpack on and wasn't speaking. The guy I knew told me in hushed tones that they had just left a funeral and wake for a guy from a Bristol collective band called the Moonflowers. The young lad had taken his own life.

The Moonflowers were a sort of hippy-punk crossover band. They lived in a big shared house up in St Andrews. I never knew them well but I went up there a couple of times with a Spanish girl who hung out with them. It was a creative space with a lots of musicians and artists from all over. A real bohemian scene, peaceful and lacking pretensions. They had it going on for a while and were making noises on the underground. When they broke up they fragmented into many creative pieces. But standing there, hearing this news was a tragic moment.

I could see Robin was in pain, shoulders hunched; he was shocked, dejected and confused as to the dark reasons for this loss, and it made me feel sad too. I wanted

to say something, to make a difference, but there was nothing. I asked him if he was in town for long but he was en route to Temple Meads station to catch a train, London-bound. I stood aside and let the group pass and watched them go down the hill, their slouched, silent forms moving off and blending in with the murk. I turned, walked to the top of the hill and stopped. I had forgotten where I was going and why.

I had never seen Robin looking so forlorn. I felt for him.

The millennium arrived but nobody really knew what they were celebrating or why. It felt pretty vacuous but it gave us all the right to get gloriously trashed. So plans were set, ideas mooted until my mate Fabbie, who ran clubs, decided to have a riotous party of bands, DJs and movies with all the added extras he was renowned for. I was asked to do the door to keep the uninvited out – not to mention the psychos who would duly show up with nowhere else to go, just

as Big Ben would be ringing out. It suited me, I actually didn't want to get alcohol poisoning like everybody else. A mouthful of champagne would suffice while I kept an eye on proceedings, and maybe a joint.

The venue was to be 'The Cube', a multi-media complex around King's Square. I spent a fair amount of my spare time there due to its eclectic underground avant-garde programme. It was a place of constant enjoyment for the likes of me who prefer their culture raw, straight up and independent.

All the preparations were done and the big night arrived. I was pleased to have this refuge to shelter in while the rest of the city would be losing its collective mind. Ours was a ticket-only extravaganza and I would be surrounded by the most splendid of Bristol's freaks, nutters and artists. It was not a bad place to be on the eve of the new millennium.

Everything was sorted out when I arrived at around eight o'clock in the evening. I spoke

to some people and picked up the buzzing vibe then I took my place at the door and waited. It was quiet despite everything, as nobody had turned up as yet.

The next thing I noticed was a lone figure moving up the hallway. The gait was Robin's. He was alone, dressed in black and hunched up. He looked up once or twice not without grace as he floated along. Things went sort of quiet, people were absent. It slowed down and I had a chance to observe him. He was a little feline, swift. I can see him even now moving along. And then, bosh, he was there – standing in front of me, looking. I think he was wearing a backpack but that wouldn't be unusual; he was probably set to run some black-ops on the eve, a perfect opportunity to make art while the town went rampant.

I could be wrong but I had a strange feeling he had come just to see me. I didn't tell him I was here tonight but that doesn't mean he didn't know.

'All right?' he said as he looked up, giving a customary nod.

'Yeah; good to see you,' I responded. There was a slight air of expectation about him so I perked up and paid attention. We exchanged a few pleasantries and he got down to business.

'I've got a question for you,' he says. I knew what he was going to ask. It had been the elephant in the room for some time and it wasn't going to be my hand in marriage.

'Yeah?'

He took a breath in. 'Do you think I should reveal myself, you know, to the press, tell them who I am, let them know and all that?'

I'd already thought about this so my answer came easily: 'No, no way,' I said emphatically. He'd brought the cold in with him and I shivered a little. I offered him a drink but he declined in an instant so I said, 'You, you're the Robin Hood dude. Everybody's going to know you, know

about you through your work. The papers are going to love you. You've got this Andy Capp appeal, don't you? From the *Sun* to the *Guardian*, you know. They'll all be talking about you. For what you've got to say. You're that good that you'll be on the tongues and in the minds of the population. You don't need to reveal yourself. You're going to be known by all anyway. And because they don't know what you look like they'll always want to know. Won't they?'

He was as composed as ever, listening, shuffling his feet a bit but didn't say anything. He obviously knew this stuff anyway. Sometimes you just need someone to confirm your own way of thinking. I probably wasn't the only one of whom he asked this question.

I went on talking, for encouragement's sake, but the main substance was said. 'Who the hell wants to be famous anyway? All those fuckers breathing down your neck. It would spoil all the freedom you've got.

You wouldn't be anonymous any more – wouldn't be able to move around the streets, that would be fucked up. It would stop you. You can have the best of both worlds: be free and your work be known.'

I looked at him because this occurrence was irregular. He had never asked for my advice before. I could tell he was really listening. That was enough deference, if you could call it that, in the absence of suitable words. He didn't nod, didn't acknowledge; the silence of consideration enveloped us and a bubble was around us. We were deep in conversation though we weren't talking. To me his rise was inevitable, he was the unique, the authentic; as sure as day follows night he would be known, he was just that good. Like an equation, you know, mathematics.

'If you make any money you should put some away,' I added.

He cut me off real quick and became animated again and said, 'No, nah, that's not important. I couldn't care less about that. I

could go back tomorrow to what I was doing before.'

'What was that?' I asked.

'Working in a slaughterhouse,' he said.

I tripped out on that. Who the fuck would go back to working in a slaughterhouse given half a chance? But it sounded true; I didn't doubt it for a second. This comment cut me down and I thought better of saying more. He was shaking his head. We came back to the room and the goings-on around us. It was the millennium's eve. Party time. We looked at each other a little. I smiled. It was good to see him at this juncture, at this impossible moment.

'Yeah, see you,' he said.

'Happy New Year,' I replied.

'Yeah, right,' he said, and then he was gone.

I thought about what he had said for a bit and then the guests started to show and the proceedings began. And what a blast they were! My mum, who came down with

one of my Australian cousins, was a little nonplussed with the hard-core porn that shockingly came on the screen at midnight and I got magnums of champagne stuck in my face from all comers, but in tiny corners of my brain I kept rerunning Robin's appearance and what he said.

Since the New Year I had seen Robin around and about and he began telling me about an event he was organizing in a central part of Bristol – an old dockside warehouse area that had been trashed and was being developed (sadly) into nondescript offices and generic dwelling spaces in the twenty-first-century fashion. Anyway, for this to happen the developers had to run several kilometres of high-board fencing round the site and that was obviously prime territory for erstwhile graffiti artists to develop their talents. However, Robin had a plan in place before the fencing was even up, discussing with the council, under a pseudonym, the possibilities of an exceptional artistic event.

For a couple of months after this he mentioned the project every time I saw him and I would listen, politely as always, to the next instalment of his unorthodox plans, and, despite my doubts, as usual, it came together. The event was to be held on a spring weekend and boasted an array of international talent. Robin was excited about it and it had taken considerable effort on his part to arrive at this point, not least his assuring a suspicious city council of the merit of this endeavour and that it would place the city on the map. I could imagine his boldness in the council chambers despite the fact that the very same council was after him for years for criminal damage on account of his continuing artistic assault. You had to hand it to him, and his impudence made me laugh. His escapades were endlessly entertaining.

The event was to go on for the whole weekend, the artists arriving, setting up shop and finishing their pieces on the

Sunday. It was a fresh, breezy weekend and chilly to be out for a whole day but that meant you could easily wear a hood if you didn't want to be too visible without it seeming superficial.

I had asked my mum if she wanted to go as I had mentioned Robin to her on several occasions by now. So we both went down quite early on the Saturday and the various artists had begun to set up. There were local names, other Brits, Europeans and Americans who had flown in at Robin's behest. He had that kind of reputation by now – movers in that world began to pay him respect when he called.

We found Robin and he was surprised to meet my mum, who rapidly produced a camera when he began to spray his work. He stopped to talk for some time, talking to my mother like a well-behaved and polite English boy would, and she was very impressed. He didn't like the camera but what can you say to someone's mum?

There began to be an easy party atmosphere as folks started to show and watch the art being created. It was intriguing to see all of these different writers putting up their long-considered pieces. The quality was exceptional; it was clear for all to see and under normal circumstances you would never catch a glimpse of a graffiti artist at his or her game. Beat-boxes were sound-clashing all around the block as dozens of painters got into a meditative flow. My mum left and I had to go do some stuff around town, returning later that afternoon.

By now more of the general public had wandered down and all seemed duly impressed. It was difficult not to be. The artists, friends and acquaintances began to refresh themselves with cans of beer as evening approached and the vibe was in full swing. As darkness fell it became their natural environment and they kept working late into the night. Robin was doing a piece which showed his tag lying comatose on an

operating table surrounded by white-coated doctors, spooks and scientists dissecting and cutting open his name. It was good but he was busy saying that it was nowhere near as good when compared with some of the legends who had come to paint and represent. Many of the new pieces going up were unique, indeed, the whole affair was unique and something to inspire the most humdrum spectator.

Sunday was sunny and balmy and a lot of the works had been completed. The entire area had been transformed. It was a magic gallery of the most intense, uncompromising contemporary art unleashed anywhere. Photographers and camera crews wandered round. More crowds ambled along, digging the free art. A lot of people were excited by the opportunity to speak directly to the artists. These were the people who put stuff up overnight, under penalty of the law; the people that make life in a gritty city more liveable through their street art. Spray-cans

of paint aren't cheap. What a way to use wasted space. I loved it. I came to sit by an artist from Chicago. He played some sublime beats while finishing his work and I lay back on the tarmac and took it in, chatting to him about his own streets and his own ideas.

Increasingly I was moving in different circles to Robin. If I wasn't in Bristol I was in Europe somewhere, along with my motorcycle. And then there was Johanna, up there in Sweden, where I was spending plenty of time exploring. London was still on my radar and I always enjoyed getting up there to see friends, catch up on the scene, attend demos against the war in Iraq and the like. I would usually try to hook up with Robin when I was up there. It was a priority of mine to see him, to keep up with him and his ideas. As always, he was worth being around and his floods of plans, cryptic as they were, delighted me. I always left his presence buzzing from his energy.

And then there were the dreams. He

had entered my dreams like none other and in those dreams our adventures were all the greater magnified.

Another dream of many: Robin and I sit silently within an ancient stone circle reminiscent of Stanton Drew under a yew tree. Wearing heavy dark coats we watch a flock of crows curve through a cold sky. We listen to them. We converse.

I: 'We have a surveillance culture.'

He: 'When negativity ceases, creativity is born.'

I: 'It is a luxury to not be recognized and deciphered.'

He: 'Creativity holds the transformative powers.'

I: 'In the future we will reject our fifteen minutes of fame.'

He: 'We are beyond them.'

I: 'Instead we will pay dear for our anonymity.'

He: 'When we are faster than them we hold an unseen space, a timeless zone.'

I: 'We create our Eden.'

He: 'The unseen place is where I operate.'

I: 'Then when they arrive there later they will see.'

He: 'Yeah, then they see and respond.'

I: 'The future is ours.'

He: 'The future will be the people's.'

I stand and throw around him a cloak of protection. In return he writes an oath with his finger on the sacred ancestral stones. A crow hops towards us, then Robin and the bird merge, become as one, and flap its wings and ascend to the azure blue of the limitless sky. I remain on my own plane, sure of life.

CHAPTER SIX: MILLENNIUM

CHAPTER SEVEN

LET US OUT

Reality was different, of course, and there was a humorous episode in which I was walking some Soho streets with him. He had a bag slung over one shoulder, as was often the case, and I knew he had several stencils in there along with some paint. I'd mentioned to him before that if he ever needed a lookout I'd be happy to provide him with some cover, another pair of eyes. I knew he did most of his stuff entirely on his own. In fact, other people would just be a hindrance to him, just slow him down. On this sunny spring day he must have been feeling generous because, as we were walking north on Wardour Street approaching the corner of Old Compton Street, he said casually, 'Stand here, look out for me.'

I saw him pull out a stencil and black aerosol from his shoulder bag. I thought we would be there for a while but as it happened, I turned, looked up and down the street, tapped my foot then looked

around to see him. He was gone and in his place was an image of a monkey flashing a V-sign at me while riding on the back of a flying missile.

'Fuck!' I thought. 'Where the fuck is he?' I glanced around but saw no sign of him. The job was done, the art on the wall like it had been there for ages. 'Shit,' I thought again and scanned the streets of Soho, full of people rushing at London pace on the pavements, but I couldn't see him anywhere.

Then I looked across Wardour Street and a face popped out from around the corner of a porn shop. He made eye contact and his head popped out of sight again. 'Fuck!' I said out loud. What a mug I was!

I rapidly crossed over, dodging the traffic and saw him nonchalantly ambling along Peter Street, so I caught up with him and adjusted my pace to his. He didn't say anything and we kept on walking. I was laughing to myself by now. He was so quick,

I couldn't believe he executed his work in a second or less and then ghosted away and blended into the city crowds, invisible and without breaking sweat, in broad daylight. I felt perhaps I had let him down, but that wasn't true really. His thoughts weren't easy to penetrate so I never bothered to apologize for my lack of synchronicity. I've been back to that corner since and relived the fun.

Sitting with Robin one afternoon in London, he relayed an interesting tale that held my attention. We were sitting in a park, chilling out and chatting, enjoying the scene and watching people passing us by when I tuned into him for what was a rare monologue:

'I was out late one night last week, doing this railway bridge in a nondescript part of London. I'm posting up some of my stencil flyers and it's dark as pitch. I'm all dressed in black, hood up, and making progress. It was dead quiet and rainy, not a soul out there.

'All of a sudden I hear this car coming so I blend into the wall. The car slowly comes to a halt below me, because I'm above the road, then they position the car across the carriageway and rev the engine and then blam! They drive straight into an electronics shop, smashing straight through the windows, glass everywhere; they pile out, three of them, bagging all kinds of consumer desirables in a cool, calm and collected manner. They barely spoke to each other. I was watching the whole thing, wondering whether to scarper or not. I saw all of it. Meanwhile another car approaches, quietly, slowly, and these three run and jump into it. Laden down with stuff they roar off down the road at full horsepower. Fucking unbelievable! It was all over in less than five minutes flat. I was frozen to the wall still, while the shop's alarm was waking up the whole neighbourhood. It was time to leave obviously. But I thought to myself, while I picked up my stuff, "Fucking hell,

look at me up here, thinking on what I was doing, they are the real revolutionaries, right in front of my eyes!" I got out of there double-quick, but I was cracking up all the way back to my place.'

I imagined him up there on the bridge taking it in.

At that time ram-raids, as they were known, were the crime of the day and since then most shopping areas have placed concrete bollards strategically to prevent such acts occurring. I could tell he was impressed by what he'd witnessed.

The summer solstice began to approach and that meant one thing – Glastonbury Festival was coming round again. I had a pass from my brother, who was working the 'drug tent' as usual, and I was to stay up at that part of the site with him in our mate's family tent. I had been across to the Stonehenge midsummer gathering and had camped out, so I rode down on the

Harley from Salisbury Plain. I arrived the night before the festival was due to start and stuck the motorcycle under a huge oak tree. The air was fresh, damp, a little cold and there was an audible hum of people arriving. Thumping beats drifted through the surrounding meadows.

I entered the main site and found my friends sitting around a campfire in boisterous mood. My old mate Phish greeted me by telling me how healthy I looked. They were making merry and that made me feel right at home. But then as the darkness fell around us, it began to rain. A little at first, and then huge, ripe, bulbous drops. I'd never seen rain like it.

We got through the night and morning broke and Phish and I decided to stretch our legs and see what was going on outside of our area, which was fenced in with security on the gate. We moved into the festival proper where people were up and mooching about. Then, smack! We virtually walked

straight into Robin. One second later and we would have missed him.

'Hey!' I exclaimed. He looked surprised. He hadn't expected such an early morning encounter, so he stood and looked at me. And then looked at Phish. And then he looked at me again. It was early, very early, and he could have been up all night (which wouldn't have been unusual at Glastonbury).

His natural reserve rapidly kicked in as we started to talk. What was I doing there? What was he doing? What was going on? We had caught him off his guard and so many questions meant that I could feel his paranoia started creeping up on him. I didn't mean to make him feel uneasy but I knew by now that his paranoia was strong and sometimes off the mark. I introduced him to Phish. They had actually met as I had taken Robin round to Phish's place previously. Robin was obviously trying to place him. Then he started to relax a little

and he was civil in all respects as we walked a little way together.

It was an unusual place to see him as nothing much went on near our area. The site was huge and most of its happenings were a significant distance away. I sensed Robin was still uneasy so I let him go off on his own, but the meeting spoke volumes about his personality. He didn't really trust anyone easily and his private self was just that – off limits. With Robin you never took up from where you had left off before. I didn't expect any great friendship. What I did was look, and observe, because there was a lot to see in him and I felt strangely protective of him and his path.

Sometime later that summer I found myself up in London visiting a couple of people and doing some stuff. One of them, Jesse, was intrigued by this character I was hanging out with so I arranged that we should all meet up in a salubrious pub down on the Ladbroke Grove end of

Portobello Road. We all made our own way down there separately. I had been tramping the London streets all day, visiting a couple of galleries and remembering haunts and hangouts from my past.

I was walking down Portobello from the Notting Hill side and it was already dark. The streets were quite empty and there seemed to be an early autumn chill settling in. Suddenly a local kid with a knife surprised me by jumping out of a doorway. I had to fuck him right off and he was not happy. This event got my hackles up and I was worried he would have some friends close by. I was angry at the arrogance of the kid in thinking I would be a soft touch for a mugging. Nevertheless, these incidents happen in life, so I made a beeline for the pub as quickly as I could.

I walked in, shook the cold off and stood by an open fire. I was already anticipating facing up to this mugger and some of his possible accomplices again and my

inclination was to just leave the area and avoid any further trouble. My own brand of paranoia and dread was doing a fine job on me but I had to sit it out and wait for my friends. At least when they showed I would have some back-up and I figured I could rely on both of them. I sat at the bar and ordered an ale and looked about. It was quiet so I took out the book I was reading, *The Tibetan Book of the Dead*. I tried to breathe calmly and turned to my last page. I sat facing the door and scanned the windows once in a while.

I was wondering who would be the first to arrive. Robin was usually late. He always chose his entrance after checking it was safe. Jesse came through the door and we embraced; it was a while since we had seen each other and we both had stories to tell as we had both been travelling – Jesse as a tour manager for the San Francisco artist DJ Shadow and me in pursuit of love.

'Some little cunt has just tried to mug

me,' I said, and I explained what had happened. I felt calmer now I was no longer on my own. Then, suddenly, the little bastard mugger came up to the window and started to look in. We caught each other's eye and I said to Jesse: 'That's him, that's him!' So Jesse looked over and the kid took off. I was on tenterhooks, anticipating a later stand-off when we exited the pub. Jesse ordered a beer and then Robin waltzed in. He was like a crow as usual: no one looked up at him as he entered the bar.

We settled down with our beers and Robin spotted my book on the bar counter. It was open face down, with the cover showing. 'Fucking hell!' he exclaimed, 'He's reading *The Tibetan Book of the Dead* here.' And he looked to Jesse for a response.

'That's Rob for you,' Jesse said, 'he's always got a book in his pocket.'

Robin seemed amused by my choice of reading matter and asked what the book was about. I started to explain but I faced

his humorous derision.

'I was talking to my Gran recently,' he said. 'She's been smoking all her life and she told me, "You know, you've got to go sometime. You could be hit by a bus tomorrow, may as well take pleasure where you find it."'

I looked at him. I was a bit put out and I said, 'With all due respect to your grandmother, a lot of people think like that. But dying from lung cancer is a fucking horrible way to go; the suffering is deplorable. You wouldn't wish it on anybody. Listen, there's a whole world of right behaviour, of being born, created, cutting out the crap, trying to live in an environment that honours yourself, to get to higher plains, to supersede the bullshit around you. If you don't honour that sacred journey that incorporates your whole life, you'll never realize where and what you could've been. Do you follow?'

He looked at me with interest and

became silent. I was hyped up after my earlier experience. Robin looked at Jesse in silence. Jesse said, 'Some little cunt just tried to mug him outside' as by way of explanation and shrugged his shoulders.

We all laughed at that, and I felt my tension bubble burst, and relayed the details of what had happened to Robin and asked what should I do if the kid with the knife was waiting for me outside later. They didn't have any suggestions, they just let my paranoia go and we drank some more ale.

A while later Jesse said, 'That really got to you didn't it, that kid?' I looked at him and didn't reply. Well, he was right, it had got to me. It seemed to me as if Robin was enjoying my paranoia, seeing my hackles raised. I wasn't often like that so perhaps he was surprised. Maybe it gave him a different view of me. I tucked the book back into my pocket and we started to chat. Robin took to a theme. 'Hey, have you ever been to London Zoo?' he began. I had passed by it

many times en route through Regent's Park and Jesse even more as he used to walk into the city that way, but neither of us had been in. We asked him why, of course, and he said: 'Well, I want to go in there when it's closed, at night.'

'What for?' we asked, looking at him quizzically.

'Have they got a penguin enclosure or something?' Robin asked.

'Yeah.'

'Well, I want to get in there and paint something like "LET US OUT OF HERE. THE FOOD IN HERE IS CRAP!" on their walls.' We both looked at each other and at him and started to laugh.

'What, you really want to do that?' said Jesse.

'Yeah, and something in the bears' enclosure too.'

'They'll fucking eat you!' I exclaimed.

We sat there drinking and laughing and suddenly Jesse said: 'Well, we can go

there now. It's not so far away.'

I wasn't sure Robin would take him up on this but he did. 'Yeah, all right, how far is the walk?'

'A mile or so.'

With that, we downed our glasses and stepped out into the dark, damp night stoked up with a sense of fun and adventure. I scanned the streets but there was no sign of my little mugger. Long gone, I thought. Nasty bastards don't usually have many friends and besides, he was probably tucked up in bed at home by now.

We walked at pace through Paddington and approached the park from its south side near Marylebone Road. The entire park was ringed with elegant, viciously spiked Victorian iron fencing that came almost up to my neck. All the gates were locked, of course, but we hadn't thought of that due to the spur-of-the-moment nature of the decision.

'Shit' we all seemed to say and our breath was visible in the damp cold night.

We looked around, over our shoulders, and decided to hoist each other over the fence. Needless to say, Robin was exceptionally nimble and was over in a flash. Jesse and I had a few problems but over we went and immediately started to tramp the distance to the zoo at the north end of the park.

While I was taking a piss against a giant chestnut tree a police patrol vehicle passed by some way off. We looked at each other and continued on and eventually the zoo perimeter became visible. It was a weeknight so things were quiet all around. We knew we were breaking some trespass law – as described in great detail on a Victorian plaque on the imposing iron fence – so we were stealthy and silent. Finally we arrived at the zoo's perimeter and could see some of the cages and enclosures with their beasts stirring inside. Some of them made nocturnal whooping calls and noises from time to time but otherwise the place looked pretty sleepy.

'What are we going to do?' I enquired. We decided that it was best for Robin to go in on his own considering he was a master at this kind of thing, and he soon found a good spot from which to hop over the wall. Jesse and I hung out behind a tree, relishing the darkness in the middle of the city and the silly caper we had embarked upon, warmed by ale. We waited maybe twenty minutes before Robin reappeared through the gloom and rejoined us.

We were full of whispers: 'Did you find it – I mean them, the penguins?'

'Yeah, and the bears.'

'Did you see anybody?'

'No, but it's a big place.'

We didn't have time to get into conversation and made our way back over to the outer circle of the park. We were a hundred yards or so from the fence when we spied a vehicle slowly circumnavigating the park. That put a spring into our step, and we charged up to the spiked fencing.

Robin was over in a snap; we leapt for the rails and as Jesse was going over one of the spikes caught the seat of his trousers and did their worst. 'Fuck!' he shouted as he sprawled on the pavement to the sound of ripping cloth.

The city traffic rushed before us. There was no blood spilt at any rate. 'Fuck, I only bought these trousers last week!' Jesse said, inspecting the irreparable damage of a twelve-inch tear. We sympathized. 'I don't care, that's the most fun I've had in ages!' he said.

We hung there for a few breathless minutes. Finally Robin spoke: 'Which way is south?' It was the opposite direction to where Jesse and I were heading, so we parted company. We walked north to Camden and recovered with cups of tea back at Jesse's place.

It was just a few months later that year that the *Evening Standard* carried the improbable tale of an intruder painting

cryptic sentences in several enclosures at London Zoo including 'We Are Bored Of Fish' on the penguin compound. Whether he got into the bears' quarters remains uncertain, but it reminds me that he always had an ongoing concern for animals.

CHAPTER SEVEN: LET US OUT

CHAPTER EIGHT

ZORRO

We were in 2002 now, and when I saw Robin again I knew he had been busy. I was beginning to see him mentioned more and more in the press. The mainstream papers were picking up on his street popularity. All of this was just the beginning: it was attention that was only set to grow and grow. He never mentioned any of this. His ego hardly seemed to exist. I would hear stuff about him from folks that had never met him. He was becoming a subject of common conversation in the pubs, on the terraces, in the streets. People felt they had some kind of claim on him just because they liked his stuff and its messages.

When I saw him again there was no hint whatsoever of any of this hubris around him. He just started to ramble on about his latest ideas, one of which was painting animals. Farm animals.

'I've got a mate, down in Somerset, a farmer, and he's all right with me using his animals,' he said.

'What for?' I asked, genuinely baffled.

'To paint on. I've found this completely harmless paint in all colours.' I just looked at him. 'Well, it's like rural graffiti. If you live in the city you paint the side of a bus or a train and you see your tag all across town, don't you? So if you're from the countryside your options are limited. So you can paint the animals. Then you see your tags all over the fields.'

I thought this was improbable craziness. 'Are you sure about this? What about the animal rights people?' I ventured.

'The animals aren't going to know any different when they're painted. It's not like I'm killing them to eat,' he replied.

I listened on. It was nuts and only something he would think of and then carry out. I knew by now that his ideas were never hyperbole. I also wondered who was going to understand it.

It was a short while later that pictures began to appear of cows with 'Wild Style'

classic tags on them. The cows seemed fairly nonchalant about their new coat of colours as they meandered across clover meadows in deepest Somerset. The pigs had some work done on them and the sheep sported some incongruous efforts on their sides too. It was an odd juxtaposition that must have been best appreciated if you were on a country outing and got taken by surprise at the sight of a painted beast.

Predictably, animal rights people were outraged but, by all accounts, the local country folk loved it. Urban culture meets rural culture at long last!

Well, truth on the side of one is still the majority and that's the template that Robin had set for himself. Taking the basic premise that free expression and free speech are the cornerstones of any democracy he had become a brilliant exemplar of that. Along the way he was becoming a people's champion too. An everyman's champion to the degree that some elements who had

previously thought they owned him began to chastise him for becoming too popular. It was all grist to the mill and he could clearly see through it all and continue with his journey, which won't stop. He's too swift to get caught on details and mental trips. Never complain, never explain; do it clean. No allegiance, no betrayal. And on.

His friendship and his story were like a thread running through the web of my life. I was moving in my own direction. I was engaged to be married to Johanna and that would entail upping sticks and moving to Stockholm to settle down. It was a good place to have a couple of kids. Johanna and I could've stayed in Bristol but I decided otherwise.

Subsequently I started to wind things up. I was increasingly out of touch with Robin. I heard about him from friends and acquaintances.

I heard how he was going over to Chiapas, the southern state of Mexico where

the Zapatistas had, and continue to have, a sustained people's revolution. I heard that from some Easton boys I occasionally played football with, who themselves used to go over there and play with the locals and get educated on how to turn the streets of Easton into an Autonomous Zone.

The news that he was going to Chiapas delighted me as obviously his political sensibility was sharpening. I was jealous of him, I suppose. In the past I had trodden similar paths. But I was older than him and ultimately I relished his youth, his freedom. I was excited for him as well because I knew he had a singular path to tread. That is what makes life a truly unique experience. Each to his own.

Jesse had invited me up to London to see him for a while before I tied the knot. It was 2003. All the preparations for the wedding in Stockholm were set; I just had to get over there for the big day. I hadn't been in touch with Robin recently; he

was off my radar it seemed. I'd been busy studying and taking exams too.

It was early evening as I mooched up to Kentish Town, a warm spring evening. Birds were in full evensong, especially the black-birds, perched on rooftops, serenading me as I approached Jesse's door. I knocked and he answered but he didn't let me in straight away.

'Hey, aren't you early?' he said.

'No, I don't think so.' We hadn't really arranged a time.

'Ah, I forgot to get some brews. Do you mind just going down the street and picking some up?' he said, and he put some money in my hand.

'Yeah, yeah, sure – no problem.' As I reversed my tracks I thought he was being more finicky than usual about the time I'd arrived but I set off on the errand nonetheless.

When I returned he was much more welcoming and beckoned me inside. I walked

his long hallway to the living room, and as I rounded the corner I was taken aback. There were two geezers standing there, one short, one tall, with pillowcases on their heads. 'What?!' I said.

'Ta Daah!' The two figures ripped the pillowcases off and it was Jack and Kes, the firefighter. I was quick to embrace them as they welcomed me and out of the corner of my eye I noticed some movement through the French doors out on the patio. Someone was coming in from the garden. It was Robin and he entered the room with a rolled-up print in his hand.

'Hey, what's up? How are you?!' I exclaimed and I was genuinely surprised to see him. Jesse must have got in touch with him. How nice. How cool. How good to see him, and of course the others too. It hadn't crossed my mind why Jesse wouldn't let me in straight off when I arrived. Now I realized the surprise he had planned for me.

Beers were cracked, the boys were

boisterous, stories related, friends berated and a few others showed up to join the party. An impromptu surprise stag party for little old me. It was an honour and a privilege to be amongst these friends.

Robin took me aside and gave me the rolled-up poster. 'Wedding present,' he said.

'Aw, thanks,' I replied as I took it. All the boys looked on as I unrolled it. It was a red background with the stencil of Queen Victoria, full of pomp, mace in hand, sitting astride the face of a nubile young lady dressed in stockings and suspenders. The boys in unison were full of cries of, 'Woah!', 'Yeah!', 'Nice one'.

'Ah, fuck, that's great, man,' I said to Robin who was standing by. 'It's one of my favourites! I see this one all the time up by the Kingsdown steps,' I continued. I could see he knew exactly where I meant even though this image must have gone up a hundred times and more in many different locations. He could see I genuinely liked it.

I was so pleased to see him and flattered to be given one of his pieces. My heart was in my throat. We looked at each other for maybe a moment too long. I said, 'What should I do with it?'

'Stick it up in your toilet, or something.' he said, and we fell back to the beers and the boys. It was getting ever more raucous.

The drink, even though there had been plenty of it, was running out so we had to do a beer run. It was late by now so one of us had to rush to the off-licence. I elected to go myself and stepped out onto the dark streets and moved off in the direction of the main drag up ahead. I had a chance to take in the occasion and its significance and to absorb the surprise. My steps were light as I tripped along under the trees, full of a beer-glow. It made me feel good that this collection of blokes were happy to wing me onwards to the woman of my choice. I went back quite far with them and it counted for something, and the fact that Robin was there made it all

the better. He seemed to be getting on pretty well with them all.

When I got back, laden down with ale, I was met with cheers. The place seemed to be in uproar. I stood in the living room while Jesse took the beers for the fridge. Robin was in the centre of a little ring of animated lads saying he would take on the hardest man there in an arm-wrestling competition. Most of the boys looked on, dumbfounded. He was West Country, deliberately stirring it. Kes, who was the hardest – and looked it – was getting riled and took him up on the provocative offer.

Robin was winding up the whole party just for the fun of it. The ring tightened and battle commenced to roars of support and good humour. They locked fists at the table and the game was under way. Robin put all he had into it and so did Kes and the game went on for some time before Kes finally got Robin's arm down flat. 'Fuck,' Robin uttered while the spectators rejoiced. Game over.

This silliness set the scene for even more revelry, as the ice was now well and truly broken.

I was being grabbed and lectured, and given some righteous 'matey' wisdom from all present bar Robin, who wouldn't presume to have any such wisdom to impart. More ale was cracked open and supped into the small hours.

Jesse, who was by now DJ Shadow's manager, interrupted the conversation to show Shadow's latest video. It was a fast-paced trip to the track 'Mashin' On The Motorway'. We all agreed it was good, apart from Robin. At this point Jesse took his moment to ask Robin if he would consider doing some art for Shadow. Shadow was good, we all knew that, and he was at the top of his game. The question hung in the air for a while. All eyes were on Robin. After some consideration he said, 'I'd rather cut off my right arm than be involved with that.'

It suddenly went very, very quiet.

'What the fuck is it with you?' I said under my breath. He didn't retract the remark, he didn't say anything, but suddenly, somehow, everybody started to laugh. It was such an extreme thing to come out with under the circumstances it could only be his humour. The boys looked around at each other and nodded, all thinking the same thing: 'This kid is a fucking maverick.'

Things quietened down thereafter and people started to ebb away, back to their lives. Robin sloped off in due course. I didn't watch him go. I knew he knew that I was on my path and he'd always liked Johanna. That was all we needed to know. To be going where you should be going.

CHAPTER NINE

ON THE ROAD

It was perhaps a year later, as an interesting postscript to this little episode, that I was passing through London from Stockholm, on my way to Bristol via Paddington Station. Jesse had wanted to hook up, but I had no time to visit him so we arranged to meet at the train terminal. I stood, my back to the wall, outside W. H. Smiths, such was the throng of people making their way in the evening rush. I loved the station; it was beautiful – one of Brunel's finest.

I'd been arriving at and leaving London through its portals for decades. Observing its rush was a favourite past time of mine but these days it was heavy with armed coppers strapped with machine guns ambling the concourse with pained expressions etched on their faces. Out of this mess came the familiar face of Jesse, sporting a pea coat, all buttoned up and carrying a cardboard poster roll. His smile shone through the crowd and we embraced. We retired to the quietest spot for a cup of tea while the crowds milled around

us. The din still made it necessary to raise our voice. 'This is for you,' he said, sipping his tea, and he handed me the poster roll.

'Yeah, what is it?' I asked.

'Take it out, have a look.'

So I did just that. There was an image of a young boy in a Zorro-type mask and cape, both his arms hanging down, with vinyl records in each hand. I looked at Jesse for an explanation. 'It's something Robin helped with; it's the cover for Shadow's latest: "The Outsider".'

He went on to explain that he had come to quite a fruitful arrangement with Robin artistically. I'm not sure if it was Jesse's persistence or Robin's contrariness that led to the collaboration, probably a mix of both. I thanked Jesse for it; it was generous and thoughtful of him.

'It's nothing' he replied. 'It wouldn't have happened without you, mate,' he said.

So I took myself off to Stockholm and married my Swedish sweetheart. However,

there was a denouement between Robin and me that I had not foreseen. After our wedding I had some unfinished business to attend to, so I returned to Bristol to tidy up some loose ends. Johanna was pregnant so I wanted to get things sorted quickly, such was my desire to be back in her arms. I also needed to ride the Harley over to Sweden, so I booked a ferry from Newcastle to Gothenburg, Sweden's west coast port, from where I could race north to the capital.

During this brief return to Bristol I asked my friend Fabbie if he wanted me to do the door for him one last time at one of his club nights, 'Espionage', which happened to be held on an old ship tethered and anchored down in Bristol's docks. It would be a good way to say goodbye to some of the local faces that would duly show up to such a legendary club night.

This old ship, *The Thekla*, had a Banksy piece on it. A grimacing grim reaper, replete with sickle, sitting in a boat, painted onto

the midship. It was a typical off–the–wall, malevolent abstraction that succeeded in twisting your mind while producing a grin at the same time. Imagining Robin stealing out in the dead of night on a rowing boat holding a lantern in one hand in the depths of a Bristol fog spoke volumes about his commitment and daring. This piece can still be seen and was respectfully kept despite a complete refurbishment of the vessel some years back.

Anyhow, the night was fun as people rolled on board and the choice music enticed the crowd to dance with wild abandon, as was always the case at 'Espionage' nights. The clock was approaching 1 a.m. and I was pretty well oiled at this point, celebrating the success of my recent wedding and life changes. Most people who were going to show for the night had already arrived and a few were beginning to leave. Then a trio of shadowy forms waltzed up the gangplank and approached the door.

I straightened myself up and then I thought I recognized the silhouette of the middle figure of the group. To my great surprise it was Robin, flanked by a brace of lads, one of whom went by the name of Mookie, a local street artist and a talent with a reputation of his own who worked citywide.

'Fuck!' said Robin. 'What are you doing here? Aren't you supposed to be married?!'

It was good to see him, really good, and we fell into a loose conversation about recent happenings. He briefly introduced me to his acquaintances while I explained why I was back in town, albeit for a short stay. We didn't mention the last time we had seen each other at my drunken stag party and I, as usual, didn't ask him too many questions on obvious subjects. I'd learnt that, with him, too much enquiring was counter-productive to friendship.

'Hey, you want to come out with us later?' he asked.

'Yeah, definitely,' I replied.

This seemed like an exciting proposition. I was hyped-up to see him and I felt pretty unruly and boisterous, especially as I was soon heading back to my new obligations. The moon was high that night, the sky clear, and a ring or haze of light encircled the moon, a result of refracted light through ice crystals high above, or something like that. Anyway, the heavens shone down in their glory and I was more than up for a spring night of merrymaking and mayhem. There was a clear feeling that the night was just about to begin and energy rang through me like a blast. In due course Robin hopped up the stairs again, along with his mates. I said goodbye to Fabbie and some others and we walked off the old ship and into the night.

There was something new on my ring finger that was unusual for me. It was itchy but I was getting used to it. A 'claddagh'

ring with a heart-shaped ruby. It winked at me in the starry light coming into the back of the car.

We were all in some old vehicle by now; there were five of us and I was sat in the back seat squashed between two – Robin and Mookie sat in the front, chatting in a hushed manner with occasional bursts of laughter. We were cruising through the City en route to Montpelier where Robin said we were 'gonna stop for a moment'. I think it was up on a one way road and the City was quiet as dust. One of them took off for a while and we sat in the frost, silent, and waited. Stuck in the car you heard all the creaks of any movement. A scatter of MDMA pills with a bird pattern appeared. I was familiar with this drug from my California days in the early '80s, but not so recently. I took one and it was quiet again, our breath visible in the chill. It wasn't too long before my body acknowledged this new interloper being absorbed into my system and anticipatory

zips of energy were travelling up my spine. I hadn't eaten in hours, of course, and now I was wide awake. This was going to be a cool night, all the omens spoke of it. I couldn't think of a better way to say goodbye to old England than this unfolding adventure.

If you've ever been through the neighbourhood of Montpelier in Bristol you'll be familiar with its terraced buildings that stagger down a steep hill, so garden walls can be very tall from the back end. I was counting my breaths for some reason when I was made to look up sharply. A fox was right in front, but above us, on a wall, eyes glowing bright, and its retinas reflecting our car lights. 'Look, look,' I said and we all turned to admire the wild city creature who was staring at us inquisitively.

It seemed to hold us in its thrall for some time before it started and loped down to the road from the wall and skulked off up the street, occasionally pausing on the brow of our hill to turn its head again to look at us,

quietly, calmly, before trotting off a few yards and then looking round again. It did that until it disappeared from our sight and we had all been silent in watching its departure. He was definitely our ally. No doubt.

Mookie came back all of a sudden and broke the spell. He jumped into the front seat along with a very large holdall. It was clinking and clanking away and he opened it up to reveal an array of painting materials, predominantly spray-cans. He was showing off his wares, which met with Robin's approval. Mookie was especially enamoured with a German brand of spray paint, which he declared the best around presently and started to explain why as we crept off up the hill in the dark, car tyres crackling on the gravel in the road.

We put on some sounds, spliffed up and had a few beers as the journey got underway to a riveting collection of cross-wire conversations from front seat to back. We coasted south, down into Somerset, the

fields and hills I knew so well, looming up at me and passing us by. It was like a farewell serenade to me and I lapped it up.

Eventually we came into a small town off the main route and there was mutual agreement to stop and get on with some art work, or as the residents would no doubt call it the next morning, 'graffiti'. There was a rush of excitement as the boys all raided the holdall full of paint. We were slap-dab in the middle of this place and they just went haywire spraying anything that didn't move. Billboards got it, walls got it, the road got it, but they were pretty respectful of private property strangely enough. I just stood in the middle of the road, coming up strongly on the MDMA witnessing a maelstrom of activity executed in lightning fashion.

There were colours, pictures and slogans. One of the dudes was in the process of a break-up with his girlfriend, so he posted up some elaborate prose on his situation. It was hilarious, like an explosion of dervishes

from the car (which was just stopped in the middle of the road, doors open), bombing all that could be bombed. Bass beats pulsed out from the car's speakers, seemingly interspersed with Wagner's Valkyries. Their natural passion was evident and they just went to it without a pause, laughing and conversing the whole time.

It didn't occur to me to paint anything; I was more into taking in the episode as best I could as the art-shock was happening so fast and hard. An arc of stars whooshed over my head, the moon gloriously fat in its fullness and the Somerset air fresh in the face. I chugged on my beer and watched it all unfold.

In one short snap it was all over and the crew stood back and admired each other's work, cracking comments and taking the piss. I was thinking we should move off and the vibe collected as we jumped back into the car. It was at fever pitch by now and was hardly containable in our confined

space as we moved off at speed to the main destination. It was there that Robin wanted to execute something that appealed to him, a new idea, as I listened in from the back.

'Where the fuck are we going to now?' I thought, as we ferreted down ever smaller, high-hedged, ancient country lanes.

We were running loose on these empty carriageways in the early hours of the morning trying to find our obscure destination. I knew a lot of these rabbit-runs as I often careered down Somerset way on the motorcycle. I peered through the windows, I didn't recognize where I was at all – no landmarks or church spires, precious little to orientate our whereabouts. And then suddenly Banksy said, 'Yeah, this is it, this is the way. This is the right road,' as the road became ever more narrow, more lost, and more leafy. We all wanted to get out and soak up the country air to welcome the coming dawn, to awaken the senses in preparation for the new day.

'Yeah, this is the place, stop, stop, STOP!'

We swung onto a patch for parking on the side of the road and fell out of the car in a reeling mass. I looked about and across the lane was a wide entrance to an old disused quarry, the way in blocked by some boulders. The place beckoned us in as the heavens brightened with the promise of the rising sun and the stars began to fade. The holdall full of spray-cans was hoisted on a shoulder and we walked in. The earlier hilarity had died down and a sense of purpose seemed to be emerging. It was peaceful and quiet with only the beginnings of a morning chorus to be heard. We whispered a bit and Robin was in conversation about his immediate plans with Mookie.

The path wound through saplings. Coming up we were met by a vast arena of high cliffs enclosing the flat ground of the quarry floor, replete with earth mounds and maze-like channels of small ravines

and little hills. Early perfumes were being released from spring flowers and the area was a sight to behold at such an hour and with our heads in such an open state.

What had brought us here apart from its secluded beauty? 'Ah yes,' I heard as the main flat grounds came into view. A litter of burnt-out, insurance-job cars, all trashed and plundered, lay about the place. Some were turned over, some sitting comfortably in washed-up mud. So this was the motive, came the realization: the urban fallout. I could imagine all these kids joy-riding stolen cars down here from faraway towns, high on adrenalin and finding a way into the quarry to scramble and jalopy the machines into total defeat and submission. It was a fine illustration of our modern world. Ballard would have loved the juxtaposition. There was an ugliness about it, of course, but these were boys who were going to transpose that and flip the picture into a new perception, that much was evident.

The mutual acknowledgement that we were all coming up to peak on the drug at the same time was met with a quietude and we all sat on a stump looking down on the pack of cars, a metal herd of redundancy. We chugged on bottles of water which someone had thought to bring. Robin discussed with the others what he was going to do. It was interesting listening to the prep-talk and then they got to it just as the first rays of the breaking sun split themselves over the cliffs. They were on a creative high, immersed in their own clouds – this was the reason for coming out tonight for them, to transform dilapidated cars into something from their imagination.

I could have easily set to it myself, just picked up some cans and chosen a car, but my mind was elsewhere. I watched Robin transform a wreck into a zebra-like creature before he took on another car and worked that into something else entirely. I was free to do as I pleased and I got up to climb one

of the cliffs. It was great just to be here, to see them settle a balance in a way that no one else would conceive of or bother with. I was off on my own trip with my own considerations and I took my chances to commune with this extraordinary place and to observe the renaissance of nature fighting back against this ravaged landscape.

I climbed for some time to the top of the quarry and found some huge boulders balancing against each other, a bit like an ancient quoit. I perched myself on top of one and whistled down to the lads so they would know where I was. I laid down and looked up into the sky, the photons flickering into my retinas. I listened to my breath and found my peace of mind, still fizzing on the clever chemicals. From there I could look down on the artists. It was typical of their ethic. They came all this way to do work that hardly anyone would ever see, because the work was the imperative, coming through them. Ego and money didn't come into it.

Expression is the key and they were busy unlocking its many doors. I was just blissing out, feeling slightly frazzled by now, and I must have fallen asleep.

I awoke, hearing some whistles. The air was still, my eyes blinked open, I wondered where I was and then it all came back to me. I took in the scene once again. Down below, like Somerset's answer to the Serengeti, was a plain full of awesome metal beasts, brightly flourishing their new colours. A pride of newly evolved creatures. Once again Robin had made me laugh. The morning had broken. It was about 7 a.m. and I made my way down to them. As I came down they started to move off, so I walked along one of the spines of the hills that led down to the quarry floor. I caught up with the crew but nobody spoke about what they had just done. As we found our way back through the saplings we resurfaced into the twenty-first century. It felt like we had been absorbed into a zone somewhere else in time

but now we were back in the real world. As we emerged through the leaves a local man was approaching us with his dog, heading towards the quarry. He was, unsurprisingly, slightly perturbed by 'young 'uns' on an early morning constitutional, but we civilly exchanged morning greetings, as you do, and went on our merry way.

As we crossed the road and approached the car the man duly disappeared. Robin said with some urgency, 'Quick, let's get out of here pronto. It only takes a mobile phone call from someone like him to set the local police on us.' His caution made sense, so we all took our places back in the car. Mookie gunned the engine and took off in the opposite direction from where we had arrived. After five minutes of silence, relaxed conversation started up and we were all still feeling good. I looked at Robin from the back seat. His window was down, hair flicking in the wind.

After we had ghosted out of the quarry,

I began some subconscious reconnoitring and started to figure out where we were. A few landmarks struck me as we rolled along these back lanes I so loved. The car was hushed and the windows rolled down. A little of the Sunday morning breeze would whisper in and stroke across us. Everything was lush, bright and green. We were driving under tree-tunnels for most of our way. It was just one of those glorious spring days, verging on summer. Ah yes, I thought, there was Vobster... church spire. We spoke a little to each other, but it was reserved and polite, not much was said, so I asked where we were heading to. 'For a swim,' replied Robin.

'You're kidding?' I said, and now I clicked as to where we were going. We were getting close to what the locals refer to as 'Paradise Quarry' near Holcomb.

I had been there many times on hot summer days with my brother over the past few years. It was a spectacular place with tall cliffs surrounding a huge pool of crystal-

clear spring water, many hundreds of metres in circumference, perfect for diving into from great heights. I had been there when countless young tykes were jumping in from the cliff edges, twenty metres high or more. It was a really sublime place to be.

As we approached the second quarry of the outing the excitement in the car began to grow again. This quarry was also cordoned off with huge boulders and fences and warning signs which, of course, did not stop us from negotiating our entrance. To be fair, there had been some bad accidents there – rare, but serious when they had occurred. But there was no way you could keep all the youth away from a place like this. Kids had made it their own after the mining had stopped.

I was on home ground now and happy to be there. An early morning dip seemed to be the perfect antidote to our drowsiness. It would clear the fuzziness from around our edges. I was also impressed that Robin's

mates knew of this place; he obviously kept good company. So we hopped and skipped and made our way deeper into the dell to an open swathe of stone. It was always a splendid sight to behold. The water was still and glistening and beckoned us towards it. The sun's rays bounced off it and enticed us. We ran the last few yards, whooping the call like the Lost Boys. We stripped down to our boxer shorts and splashed or dived in.

The place was quiet and serene with not a soul to be seen, apart from some wildlife that retreated to the surrounding woods. The water was invigorating and I swam out to one of my favourite corners of the cliff walls from where I could climb up a way to dive back in. It was a couple of hundred yards of swimming and the water was bracing enough to take the breath away. I reached my spot, climbed up and took in some of the sun's rays. By now Robin was halfway out in the water, all on his own, observing me in silence. I dived back in, relishing the feeling

of re-entry, and swam underwater some way towards where I thought he was. I spotted his legs before I came to the surface, out of breath, sucking in some air. He was smiling at me.

For Robin to smile was a rare occurrence, despite his obvious dark humour. I looked at him, fresh-faced, both our eyes were bright and we were as cold as fuck. We could've been seven-year-olds, we felt so alive and abandoned to nature.

'You all right then?' he said.

'Fuck, yeah,' I replied.

We treaded water for a while. 'How was the wedding?'

'Good. Really good.' I showed him my ring for a second.

'That's good then, fucking great, well done. Nice girl.'

'Yeah,' I nodded. 'Yeah. Hey. I'm really glad to be out with you, you know, here, the whole night; all of it. It means something to me,' I said.

'I know,' he said, and then, 'C'mon. I'm fucking freezing.'

He ducked back into the water and I followed suit and we swam alongside each other back to the quarry's only sloping shore where the other three were messing about. They had found a little boat and were paddling around in it like chumps, goofing around like crazy kids. It was hilarious.

Eventually, we all got out and sat on a big rock and spliffed up. By now we were all renewed and energized. We smoked and chatted; it felt really free and totally cool. I was loving it. An eclectic bunch sitting together like the good friends from 'Tales from the river bank'. What a way to begin a new day.

CHAPTER TEN

OLD ALBION

We left Paradise Quarry in good spirits and lazily navigated these back roads of Avalon. Mists were still lying in meadows and cow parsley brushed the car and came in the open windows. Falcons and larks were up, flocks of crows specked against the landscape and we caught sight of a few hares dashing about.

After a while we saw some parked cars along the lane. A space opened up and in a small field there were a few dozen cars parked in an orderly fashion with their boots open.

'Yeah, a car boot sale, let's stop!' It was around 9 a.m. and the traders were just beginning to set up. We were likely the first customers and piled out of the car to knowing looks. We straightened up. The folk were pleasant and cheerful and we responded in a like-minded manner. The smell of freshly baked cakes and biscuits wafted past us and, as one, we followed the trail to the cake-stall, the first port of call at

any jumble or car boot sale. As by now we were ravenously hungry we splashed out what cash we had to the delight of the West Country lady selling the cakes – lemon-drizzle, scones, biscuits, fruit bread, and more. With handfuls of goodies each we found a space to sit down and have a breakfast picnic, along with mugs of fresh tea. Not bad, not bad at all. We chatted and ate and rose again to look at the wares for sale.

There wasn't too much of interest but we did the rounds and I picked up a book. Robin was looking at a fluffy toy rabbit over and over again. I wasn't sure why. He bought it and came back over to sit with us. It was fair to say that we were all pretty spaced out by now and sentences trailed off into nothing. I asked Robin why he had bought the rabbit. 'For my niece,' he said. Then he started to play with it. He walked it over to me and put on a silly voice, which was funny enough, and then he said in his rabbit words: 'What's death, Mr Robert?

What happens when you die? Tell us?'

It was sort of an odd question and it took me back to my outburst in the pub in Portobello Road where he had been ribbing me over my reading of *The Tibetan Book of the Dead*. I took the rabbit and walked him along my knee a little, picking up the thread. 'Well, you know, Mr Rabbit, death is like a long dark tunnel that you move down in some way, which may scare you a little, but what you do is you just keep on going, towards the light. You just ignore all demons and head towards the light. Do you understand? And then you'll be okay,' I said as I looked at him. Robin took the rabbit back.

'Yes, yes,' he said. Everybody looked on as Robin walked the fluffy toy back to him. It was quiet, we dazed and dozed. Then Robin perked up and said out of the blue: 'Hey does anybody know how to cook the perfect egg?'

'No'.

'Hey?'

'No'.

'Tell us then.'

'I saw it on "Nigella Lawson", on telly.' We laughed a little at that. 'No – what you do is, she says, you should just put the egg in cold water, bring it to the boil, with a little salt, and when it's just bubbling, just take it off the heat and let it rest for a while and then you've got the perfect egg.'

We raised our eyebrows. It was off topic but, hey, now we knew how to cook an egg perfectly. I've tried it since and always cook my eggs that way. By now our heads were elsewhere. Eventually someone said, 'C'mon, let's get back.' So we moved on again.

When we returned to Bristol some of us had been dozing in the car. We awoke to a mid-morning lazy Sunday, the streets empty. We dropped one or two off and we headed over to Easton to someone's house. It was cool and shaded inside, sun blazing into the garden. I popped out and bought some fruit

and halloumi from St Mark's Road so we could make a fruit salad. When I returned Robin was packing a bag.

'I've got to go, got to catch my train back up to London.' He looked slightly downcast and became quiet. 'Can't you stay and eat?' I asked, as I placed the things in the kitchen.

'No, I didn't realize it was so late, I've got to leave.'

'Okay.' I said.

He picked up something to put into his bag. It was a helmet, not a motorcycle helmet, some other type. 'What's that?' I asked.

'Riot cop's helmet.'

'Yeah? Let's have a look.' Robin put it on.

'I bought it off a mate,' he said.

'Looks heavy! Do you feel like a cop with it on?' I asked.

'No, it's surprisingly light – try it.' So I put it on, and yes, it was very light. Much lighter than my motorcycle helmet. It had a visor and neck flap for protection against rear blows.

'These coppers look so hot and sweaty with them on usually,' I commented and I handed it back. That was enlightening, trying on a riot policeman's helmet. I wondered about how he came by it; how the copper lost it, and followed my train of thought. It was typical of Robin wanting to own such a thing. It was like a research item or something.

He didn't have long as he had called a cab when I was out buying the fruit. Time was at hand and I knew I probably wouldn't see him for a while. He wasn't the kind to write. I had invited him to Stockholm to visit but I didn't expect he'd make it over either. He was on another tangent. I'd known him for seven years by now and followed his meteoric rise. Some say life goes in seven-year cycles. Who knows, maybe? I was off to continue on my way and I knew too that big things were waiting for him and in that moment I said so. 'I guess you've got to go, they're waiting for you up there, big things waiting for you.'

He looked up; he was a little more downcast than five minutes before. The house was dark and quiet.

'Taxi's here,' said the other guy from the front room.

Robin picked up his pack, about-turned, looked over his shoulder at us and was gone. There was a sudden void where he had been standing. The place seemed empty. The two of us that were left made the fruit salad and sat out in the garden in the sun and ate. We spoke about this and that but behind our eyes we were both seeing in each other that we missed him already. He'd gone and that was that.

EPILOGUE

And so, now we close. I've been over in Sweden having some kids and roaming the Nordic wastes for another seven-year cycle. I'm often back in England and I've observed Robin's continued ascendancy, the endless newspaper coverage and the 'looking for Banksy' hysteria. The kid is front-page news. His incursion into museums, his movie, he follows a line from Chatterton to Cary Grant, a lone rebel genius from the city of Bristol. He's shown you can be famous without being known and that has got to be the best sort of fame – a whole spectrum away from cheap, gaudy, desperate celebrity. He shows up the complete and utter vacuity of celebrity. I would never wish that kind of fame on him, it's like a curse, Coleridge's albatross, weighing you down. It's just not worth the money.

The establishment want to take bites out of him although they could hardly give a fuck about his messages. Where there's money to be made, who cares?

I've seen, too, on the other side of things, his work trashed by holier-than-thou street politicos who believe his graffiti brings with it gentrification. He moves all sides into a fervour, that's quite an accomplishment.

Now, someone like me is obviously going to defend him. I've always loved his appropriation of images from the news only to transform them into iconic images of insurrection. I've always loved his humour and its dark, melancholic edge he can't shake off.

But now he's through the mirror, on the other side. It's where he wants to be yet I don't think he should become too comfortable with that, to lose sight of himself, to forget those who supported him, who would not reveal his identity for any kind of money. He doesn't owe anybody anything, that's not it. Simply due to their acceptance of him, he has become part of the establishment, but they don't deserve him and from my corner he should rock their boat more than ever. There's a lot of us

that don't want him to become 'flavour of the month' only to pass on into oblivion. That's the way the establishment will treat him. He's worth more than that. Not just another pop icon to be worn on a useless T-shirt.

I hope his clear-sighted irreverence continues if only because his work brightens up the Ballardian nightmare we reside in. What a shame it would be for us if he lost his vision, by being cosseted in success. We want him to live out his artistic potential for the rest of his days, because he's got it. He's got the right stuff.

Can Banksy live up to his reputation? That's the final question and I have faith, perhaps due to the countless number of times I would meet him and he started the conversation by saying, 'Fuck, I was being chased by the law again last night. A real hard chase, over bridges, railway lines, across roofs and roads... they nearly caught me this time – they nearly had me!'

ACKNOWLEDGEMENTS

Johanna Köhlin-Clarke, Elisabeth Mary Clarke,
James Clarke, Jamal Chalabi, Ryan Broom,
Paul Horlick, Simon Doling,Simon Adams RIP
Thanks for your help.

PICTURE CREDITS

Page 1 Åke Eson Lindman
Page 2 Åke Eson Lindman
Page 3 Johanna Köhlin-Clarke
Page 4 & 5 Elisabeth Clarke
Page 6 & 7 Elisabeth Clarke
Page 8 Getty Images
Page 9 Elisabeth Clarke
Page 10 & 11 Johanna Köhlin-Clarke
Page 12 malcolmfreeman.com/Alamy
Page 13 Zak Waters/Alamy
Page 14 & 15 Top Getty Images,
 bottom Johanna Köhlin-Clarke
Page 16 Top Getty Images, bottom Johanna Köhlin-Clarke
Page 17 Getty Images
Page 18 Getty Images
Page 19 Luz Martin/Alamy
Page 20 & 21 Top Getty Images, bottom left Rod Ward,
 bottom right Johanna Köhlin-Clarke
Page 22 Ian West/Press Association
Page 23 Rex Features
Page 24 AFP/Getty Images
Page 25 Wesley Johnson/Press Association Images
Page 26 Getty Images
Page 27 Adrian Pingstone
Page 28 & 29 Main Sophie Duval/Empics Entertainment,
 bottom left Johanna Köhlin-Clarke
Page 30 & 31 David Brabyn/Corbis
Page 32 Johanna Köhlin-Clarke

INDEX